Let's Be Reasonable

Pearl and Ervin Bergt
at the family farm near
Schuyler, Nebraska,
on their fifty-seventh
wedding anniversary.

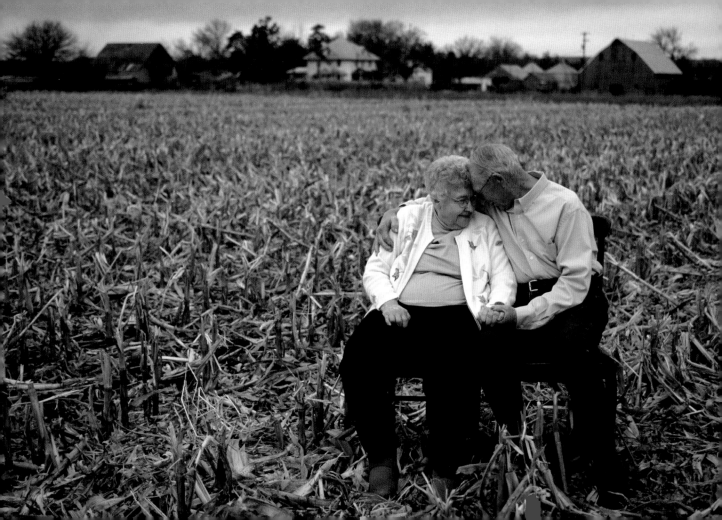

Let's Be

Reasonable

Joel Sartore

University of Nebraska Press | Lincoln and London

© 2011 by the Board of Regents of the University of
Nebraska. Text © 2005–2010 by Joel Sartore. Photos
© 1985–2010 by Joel Sartore. All rights reserved.
Manufactured in China.

Publication of this volume was assisted by a grant
from the Friends of the University of Nebraska Press.

Library of Congress Cataloging-in-Publication Data
Sartore, Joel.
Let's be reasonable / Joel Sartore.
 p. cm.
ISBN 978-0-8032-3506-9 (cloth : alk. paper)
1. Photography, Artistic. 2. Sartore, Joel—Philosophy.
 I. Title.
TR655.S279 2011 814'.6—dc22 2011004432

Designed and set in Scala and Scala Sans Pro by A. Shahan.

Five-year-old Sam Sartore
shows his displeasure
with having to get his picture
taken on a cold fall day.
Oddly enough, ice cream
seemed to revive him.

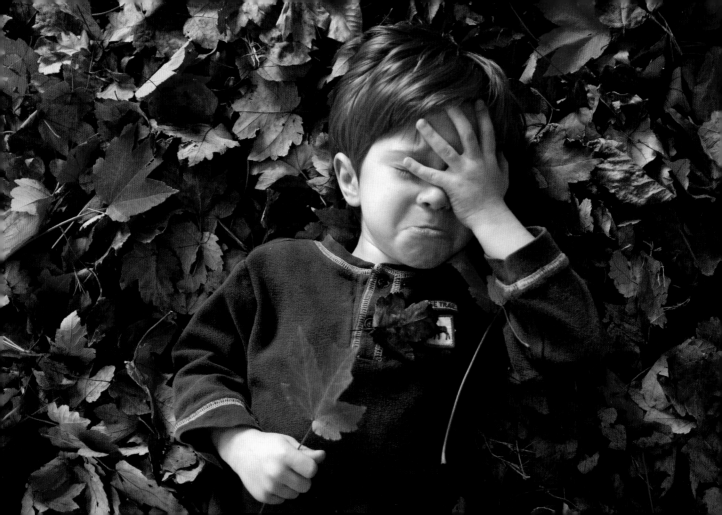

To my children, Cole, Ellen, and Spencer.
May you always keep an open mind.

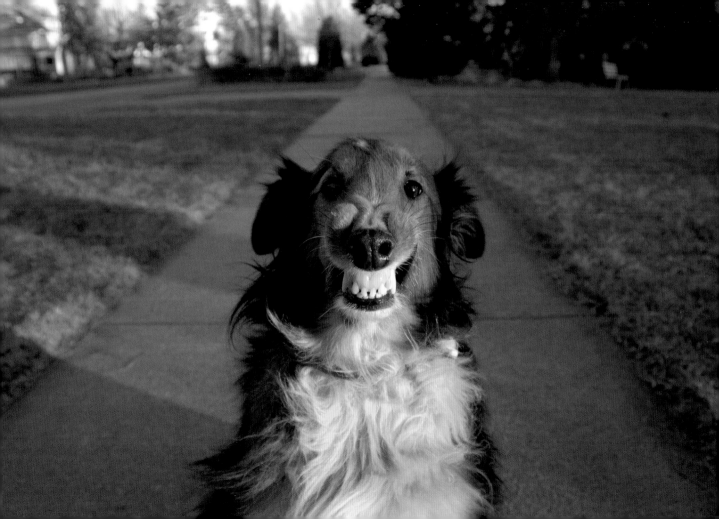

Introduction Let's Be Reasonable

If you really want to know the truth, I'm irritated.

Many folks today absolutely refuse to keep an open mind about anything. No matter what facts come at them, their clay has set, leaving them to spend their whole lives defending bad ideas. Since life is about constant change, this sure seems like a waste of time.

While some of these essays are simple observations, many are designed to get people to think, and then act, differently. It bothers me to no end that we're so wasteful as a society, or that we care so much about the price at the pump and what's on TV, that we ravage the Earth in search of riches, and that

You're looking at the only trick photograph in this book. I trained my dog, Prairie, to tolerate fishing line under her lip long enough for a picture to be taken. Her tolerance was then rewarded with a Milk Bone.

the march of time eventually beats any hand we could possibly draw.

But it's not all a rant. Some are just musings set to pictures I've taken over the course of twenty years and thirty stories with *National Geographic* magazine. Throw in a little humor and you've got a little book. Good thing it's cheap.

This all started with a phone call from a public relations person at the National Geographic Society. She said *CBS News Sunday Morning* was looking for pictures of crops in the field for their annual Thanksgiving show. As an avid watcher of the program, I thought I'd do them one better than that; I'd write a little essay to go with the photos and read it on air if they'd let me. They did. That was many years ago.

It's an odd thing the way your perspective changes with time. At first I only wanted to write about the mundane: the way mud clings to all of us each spring, the weather, even laughter.

But as I've gotten older, I've read the obituaries enough to know that no matter what the phone company says, none of us have an unlimited supply of minutes. So I hurry up and get

That's the one we try to live by, to be grateful for what our five senses take in on a daily basis.

the important stuff out while I still can. This led to writings ranging from how we produce oil on Alaska's North Slope to how we spill it in the Gulf of Mexico.

Of all the essays I've ever written, it's the one on my wife's battle with breast cancer that I'm most proud of. She's fine now, which colors things terrifically of course, but that's the one that sticks. That's the one we try to live by, to be grateful for what our five senses take in on a daily basis.

I truly appreciate any given summer day, when thousands of Nebraskans sweat in the baking sun to produce what ends up on my kitchen table. I like the way the crops look in the field, lined up perfectly and weed free. I appreciate how that food eventually tastes, and that each evening meal draws my family together in a chatter-filled blur, noisy, happy, satisfied.

I'm proud of the fact that I own a farm pond, and that my dad has lived long enough to fish it with me. We just do catch and release now. The sound of cicadas all around tell us that summer will soon be over.

I like the smell of wood smoke on the first cold day of fall and

of steaks cooked outside once it's finally cool enough to stand over the grill again. Just for a moment it seems the red ivy on my house is as brilliant as any sunset.

Next up, the first real snow of the year redeems even my lousy-looking lawn and quiets traffic at the same time. When winter storms come and the school warden pardons my anxious children for the day, they act like it's Christmas, and in a way it is.

And in the spring, when the wildflowers finally push up, I take my kids out mushroom hunting, usually in the hills along the Missouri. We try to stay on our side, but sometimes the promise of more morels just to the east is too much to bear. We make a big deal out of the fact we've left the state, parking close by so that we can see Nebraska from the river's edge as we hunt through Iowa's cottonwoods, some so old they knew the pioneers.

And at dusk, when we can't see the ground anymore, we drive west, and let out a cheer on the bridge as we pass under that bright green sign with the promise of a good life.

We're home again.

Thanksgiving place setting at the Trumble farmstead, Papillion, Nebraska.

OVERLEAF: Shoot first, ask questions later.

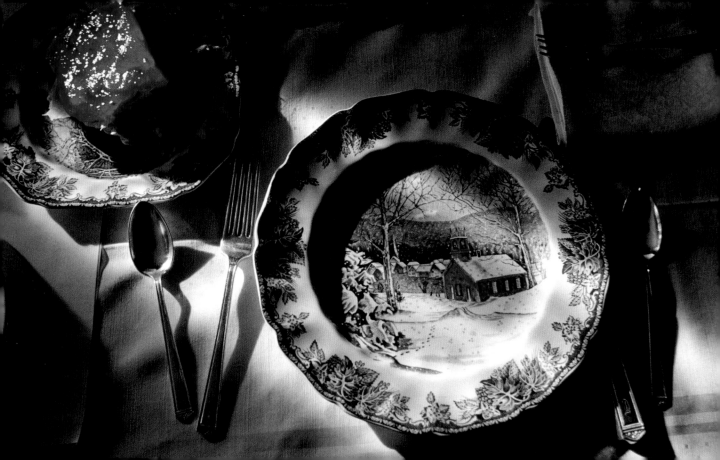

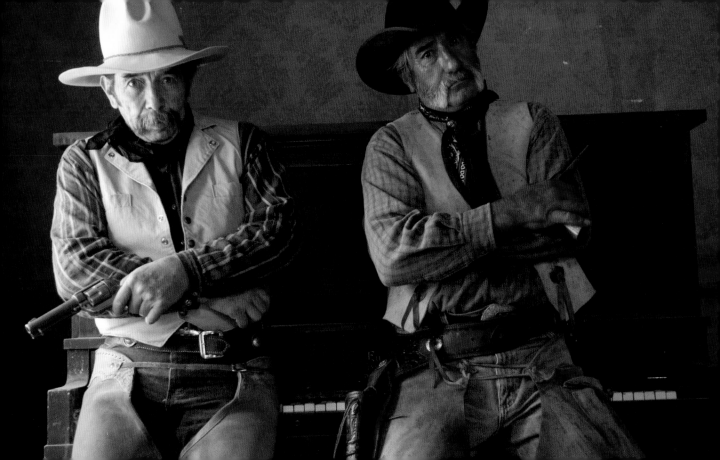

Let's Be Reasonable

Thirty Years of Photography January 2009

Thirty years ago I picked up a camera for the first time. I used it mainly to try and impress girls. Unfortunately, they found it creepy and would have nothing to do with me.

My pictures were truly awful back then: my first car, my dog, my brother holding a turtle. Worst of all was "The Frogburger," a terribly executed food illustration in which I thought it would be a good idea put a live bullfrog in a hamburger bun. All he did was hop away and get mustard on the carpet.

Branching out in college, I often shot in black and white, images of parties and friends mostly, documenting foolishness.

An early photo, before I had any common sense.

At least photography was simple back then. It was all film and prints, nothing more, tangible and held in your hands.

People don't use film much these days. We've gone digital. That's a good thing, I guess, because storage was a monster. In all those years of exposing film for *National Geographic*, I shot a half million slides. Now they're all in my basement.

Today, besides creating a physically smaller body of work, digital has revolutionized picture-taking. We can now shoot in nearly total darkness, and we can see our photos as we're taking them. No more bad exposures. No more out of focus. If you don't like something, just delete it and move on with your life.

But all this gee-whiz technology comes at a very high price. Professional cameras routinely cost at least five thousand dollars. The machines needed to extract the work, and the people to run them, cost many thousands more.

Yet the storage beast hasn't really gone away, it's just shifted. And this, in my opinion, is digital's Achilles' heel.

Twenty years with *National Geographic* have yielded a half million slides and almost as many digital files.

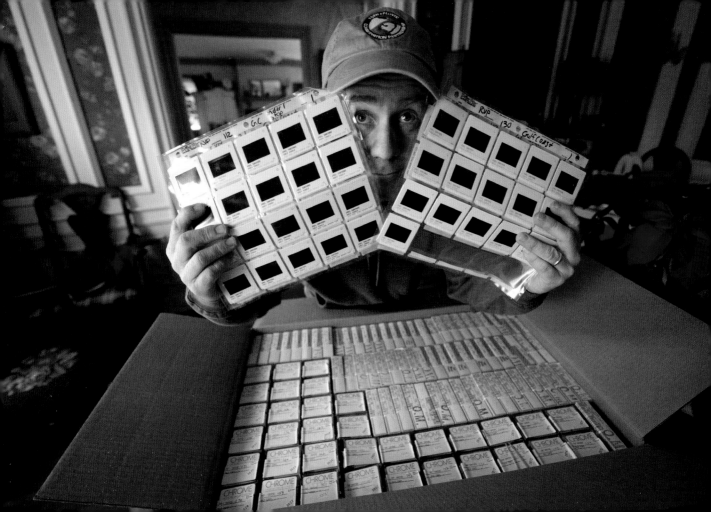

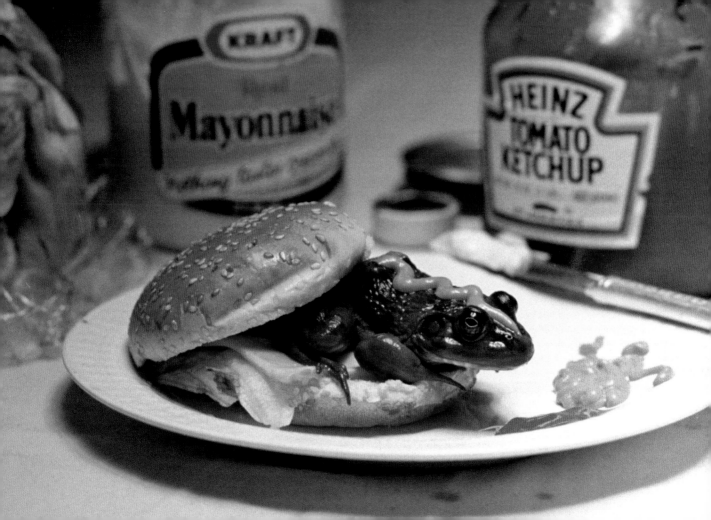

That digital photo you take today is only visible with the aid of a computer. It's then stored on DVDs or hard drives or online, all of which change relentlessly. This worries me.

How will any of us save and then find our photos in the future? I don't think we will. Unless you stay on top of the latest software and storage, or make archival prints, you could easily lose those precious memories.

In the end, this may be the real price we pay for progress.

That frogburger picture is looking better all the time.

Because it was so twisted, this frogburger photo helped me land my first job. After the photo, the frog was released unharmed into the farm pond from whence it came, sans mustard.

Conspicuous Consumption January 2009

I used to look at the holidays with such reckless abandon. I mean, as a kid what's not to love?

But now that I'm older, I've noticed something awful about this time of year: The waste of it all.

First, let's take the high holy moment of conspicuous consumption: Christmas morning. Twenty minutes after we're downstairs, my kids are literally swimming in debris.

Second, have you ever looked around at what gets thrown away the next day? I have, and it really depresses me.

Christmas morning.
Do we really need
this much stuff?

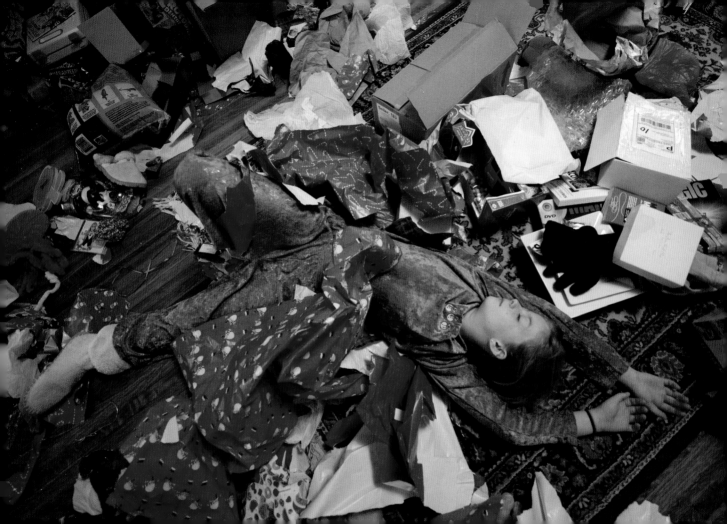

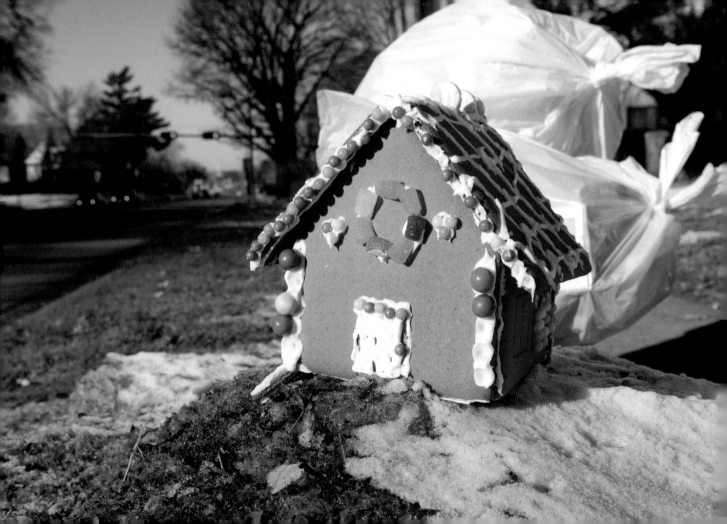

Piles of stuff are everywhere, mounds of it, including the gingerbread house, and it's all headed for the landfill. Spent wrapping paper is even wrapped to look like wrapping paper.

This is the path to madness.

And the poor Christmas tree. What went wrong? We put all that effort into picking just the right one, decorating it with care, showing it off through the living room window. And then it's over. Out on the curb. Tossed out like a cup of rancid eggnog.

But don't think our wastefulness stops there. Oh no, Christmas is just high tide.

We're plenty wasteful all year long.

On trash day in my neighborhood, I get in my old pickup truck and cruise the curbs, eagerly looking for good stuff. It doesn't take long.

In the spring I find snow blowers and shovels and space heaters. In the fall I see lawnmowers and rakes and fans.

Throwing it all away,
after Christmas Day.

9

It's as if my neighbors don't know that all the seasons will eventually come round again.

It's amazing and disgusting all at once. Why would anyone throw away things that work? They could get a tax write off if nothing else, and many charities will come and pick it up for free.

I could go on and on. I find tools, toys, and artwork. And the antiques, holy cow. I've gotten a rolltop desk, a cherry settee, an Eastlake table, and many rocking chairs. My house is loaded with this stuff.

But curb cruising isn't pressure free. I feel terribly guilty if I don't go out on trash day because I know that everything I don't save will eventually be crushed to death in the dripping, roaring maws of a garbage truck. All this drama, just on my little route. I'd go crazy if I thought of what was being lost across the entire country.

I've got a couple of theories on why we throw so much stuff away. First, we live in a disposable society. It's cheaper to buy

One trip to the landfill would make a recycler out of anyone.

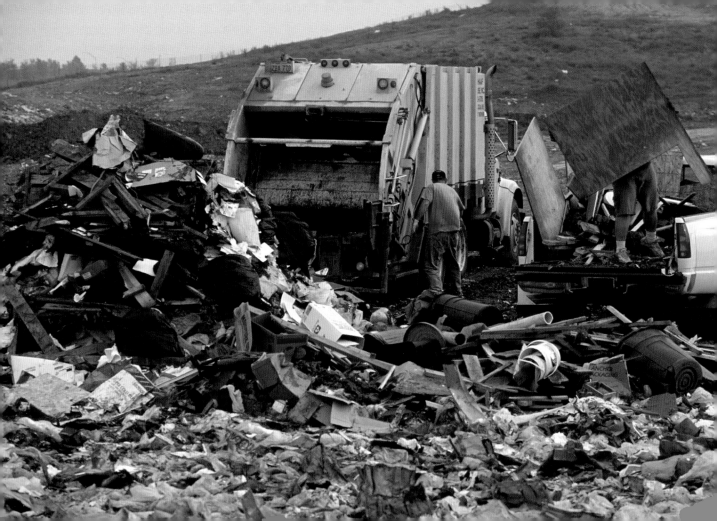

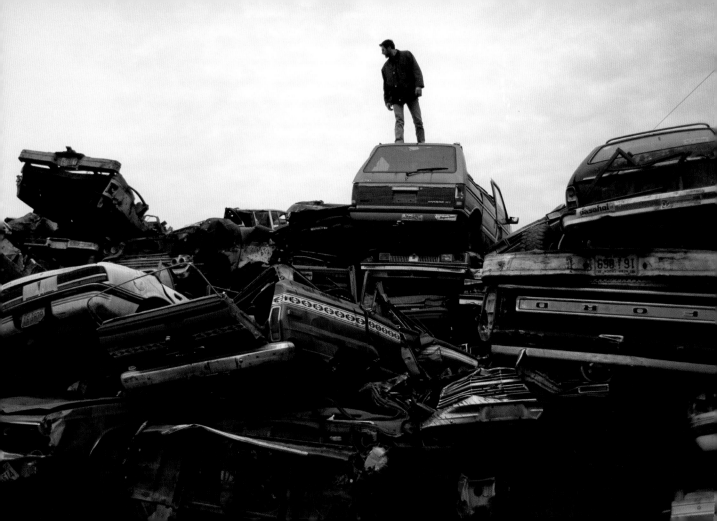

new and often impossible to get something repaired. Retailers like it that way.

Second, Americans just don't think about what they're doing. We're very nice people, but advertising and peer pressure mandate that we buy things, lots of things. Our holidays are based on this. Indeed, so is happiness itself.

So please, think about what you're doing on the eve of trash day. But if you can't, and you're going to toss something good, give me a call. I'll be right over.

Americans throw away
mountains of cars and trucks
every year, and it shows.

A Trip to the Zoo March 2007

Winter in Nebraska consists, frankly, of short, dark days and cold, hard ground.

So what to do?

I went to the zoo.

Actually, I went to several. And, of course, I took my camera along. I'd feel naked without it.

I thought I'd do studio-type portraits of anything that would hold still. Sometimes the shooting went very well. Take turtles, for example. They'd just shell up and look at me.

But sometimes it was pure misery. Small primates never, ever hold still. I wonder how they sleep at night. The same holds

An African elephant at the Cheyenne Mountain Zoo, Colorado Springs, Colorado.

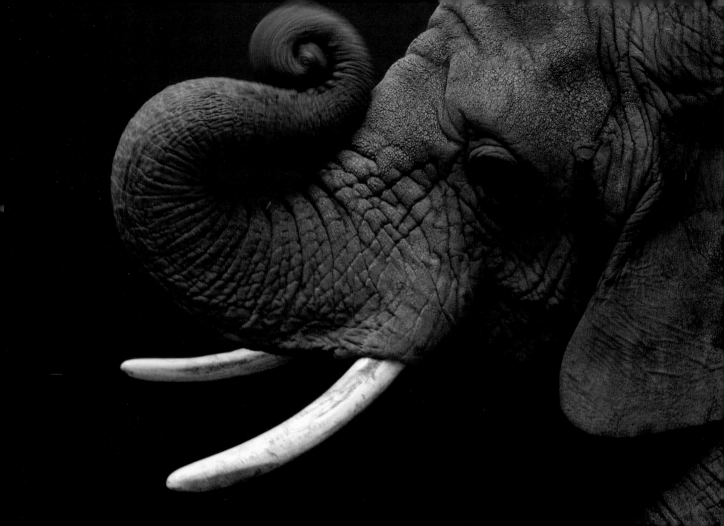

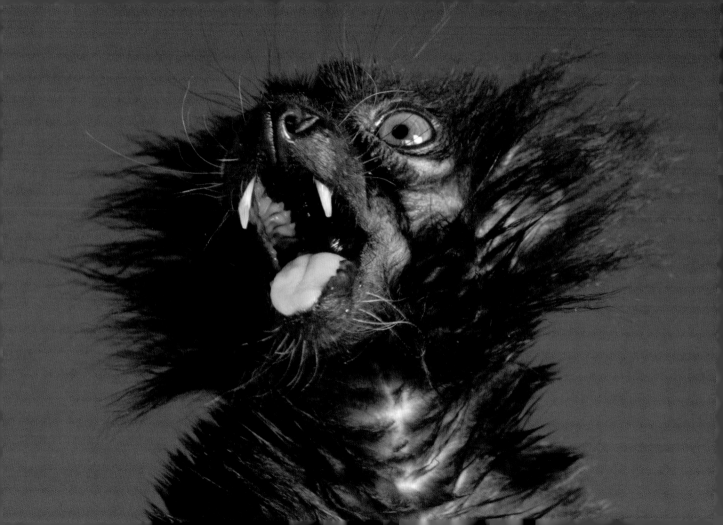

true with naked mole rats, by the way. Very squirmy. And some animals hated my paper backgrounds.

But through it all, I couldn't stop marveling at the diversity I was seeing. Every niche in nature is filled. Adaptations to all manners of wet and dry, hot and cold, predator and prey, animal bodies are tools for eating, hiding, mating, for staying alive.

But if you can see past their looks, you'll soon notice the similarities between us and them. Zoo animals get bored and hungry, excited and angry. They have good days and bad. They are just like us, actually, except they're often better behaved.

Oh sure, we can see animals on TV, but it's all about bear maulings and shark bites these days. It's pure sensationalism.

What the zoo gives us is a rare glimpse at the most amazing creatures. To think that an armadillo makes his own armor, or that a pallid sturgeon uses its nose to find food and a mate in dark roiling water. That's miraculous to me.

And what do zoos give animals? Survival. For many species, zoos are modern-day arks. The black-footed ferret wouldn't be here today without the help of intensive captive-breeding

An ancient black lemur
at the Bramble Park Zoo,
Watertown, South Dakota.

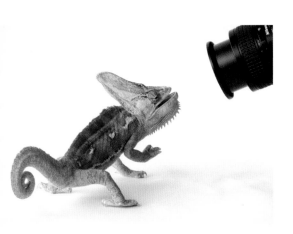

efforts. Same story with the Wyoming toad, the California condor, and many others. The list is far too long, and growing.

Of all the things that I've seen at zoos, none have moved me more than the amphibians.

They're so varied, and yet so small and delicate, with a permeable skin that allows all manner of toxins in. True environmental barometers, it's a wonder they've survived at all.

I'm trying to concentrate on the amphibians now because a warmer Earth may be allowing a disease called chytrid fungus to spread. It's often fatal to any frog, toad, newt, or salamander it comes across. Biologists expect we'll lose half of all amphibian species within the next ten years. I think folks should know that.

After all, if you think about it, there's as much surprise and intrigue in a Budgett's frog as there is in the roar of a lion. What a warm thought to make it through these final days of winter.

And so I go. And I stare. And I wonder. And I know it's time well spent. After all, the view is tremendous. I can see the whole world in the eye of a frog.

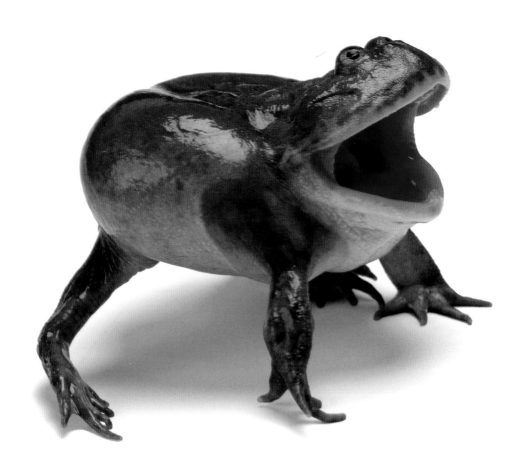

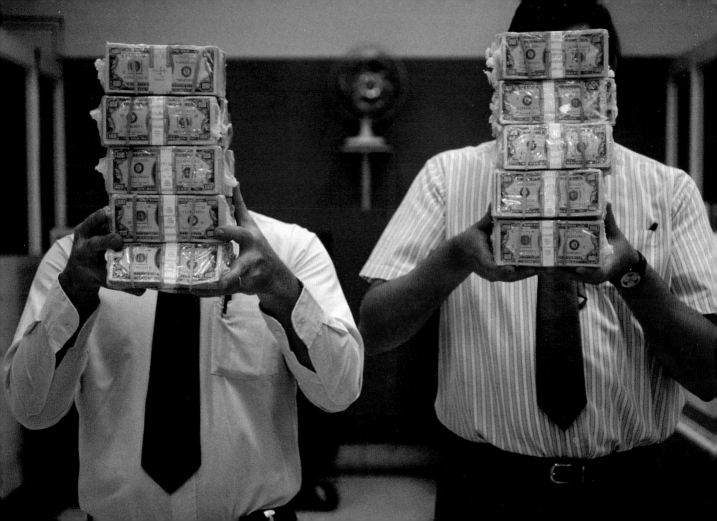

Money February 2008

Did you know that the average dollar bill contains trace amounts of cocaine?

It's also a great vehicle for both staphylococcus and streptococcus bacteria.

I guess that's why they call it filthy lucre.

But put that out of your mind for a second and take a quick tour of a Federal Reserve Bank with me.

Guides held a fresh, crisp twenty up to the light to show the anti-forgery strip embedded within.

At the Federal Reserve Bank in Boston, twenty-two pounds of hundreds equals one million dollars.

I asked to photograph a million bucks. That's twenty-two *pounds* of hundreds. No problem, they said, just don't show the faces of the folks holding the money. When you're only rich from nine to five, it's best to remain anonymous.

At the end of the tour, they gave each of us a little packet of shredded money, just for fun.

I came out of there thinking differently. Money meant more to me now. I realized I could hold history in the palm of my hand.

Back home at a coin shop, a thousand faces wait for someone to notice them on any given day. If only they could talk. What goodness, or trouble, have they bought? Don't they get tired of being thumbed?

Nothing feels quite like paper money. That's probably because paper money isn't paper at all, but, like a nice shirt, it's mostly cotton and linen. That's why it'll hold up in the washing machine.

And just look at it.

Sure, all those intricate drawings are there to make counter-

. . . paper money isn't paper at all, but, like a nice shirt, it's mostly cotton and linen.

feiters earn their pay, but along the way, money became art. Every inch contains vintage details, finely hewn yet mostly unnoticed, and now found flourishing only on old buildings.

As if that weren't enough, there's a new line of paper currency in all the colors of a rainbow. I guess the Treasury is trying to make pay day fun again.

Direct deposit? No way! I'll take my pay in Benjamins, please, and Toms and Georges, too.

Just remind me to wash my hands.

Damaged bills are shredded and given out as souvenirs after a tour of a Federal Reserve Bank.

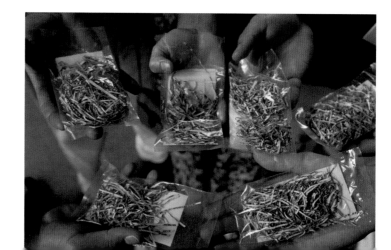

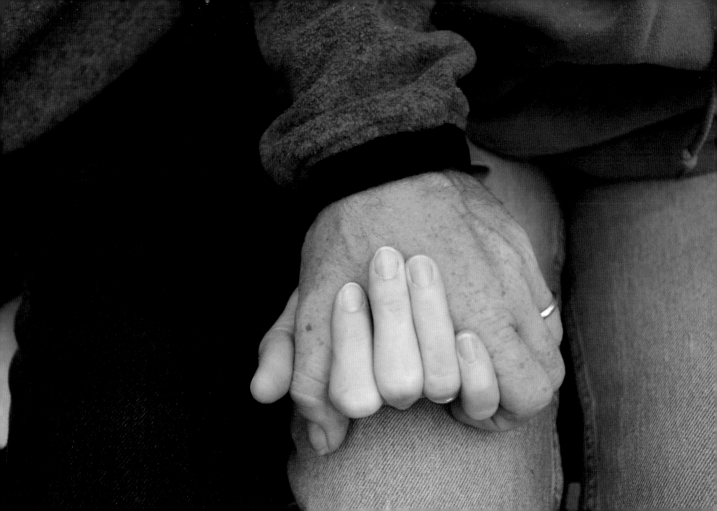

Cancer October 2006

We all have our ways of marking time. As a *National Geographic* photographer, my life is measured from one story to the next. I bought my first house in Nebraska while I was on assignment shooting America's Gulf Coast. My son was born in the middle of a long story about the Endangered Species Act. My daughter came along with a pack of gray wolves.

Twenty stories later, it's the story on Alaska's North Slope that I'll remember most. It was about the loss of wilderness and innocence—and the story during which my wife got cancer. That's the one that made time stand still.

We don't talk much.
We just hold hands.

We met in college, at a blues bar. She had long blonde hair and thought I was funny.

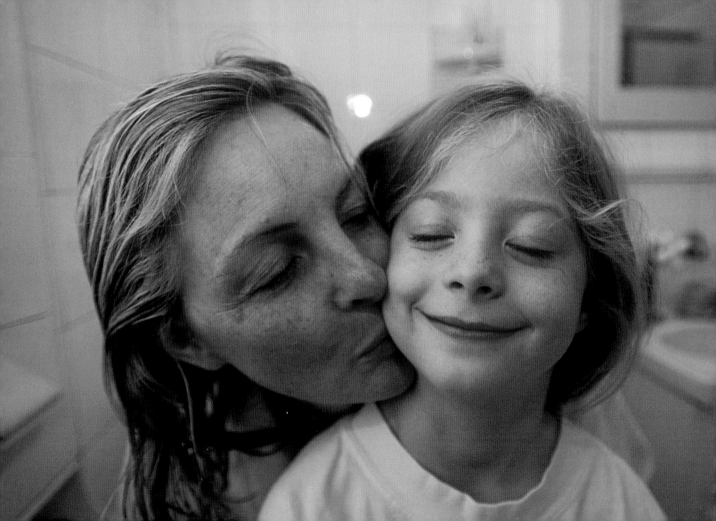

My wife, Kathy, with
our little girl, Ellen.

Beautiful, graceful, and patient, she has remained my muse for twenty-two years, despite the thousands of times I've forced her to be photographed. She may have gotten tired of it now and then.

The picture taking pretty much stopped, though, on the day she found that tumor in her right breast. It was the size of a hen's egg. Weirdly, it was Thanksgiving. By Christmas the chemo had her weak and bedridden. Some days she was so sick she couldn't watch TV. One day she couldn't even talk.

Early detection saves lives. But ours was not early. By the time you can feel it yourself, it's bigger than the doctors want it to be. A surprise baby had distracted her from two annual mammograms. Now I'd pay anything to go back in time.

Cancer is a thief. It steals time. Our days are already short with worry. Then comes this relentless disease, unfair as a hailstorm at harvest time. We instinctively knew to brace for the worst.

Kathy went for chemo every week. The oncologist took blood, gave percentages, told us we were doing great. But he's been

Catching snowflakes.
This is the good stuff. This
is what we're living for.

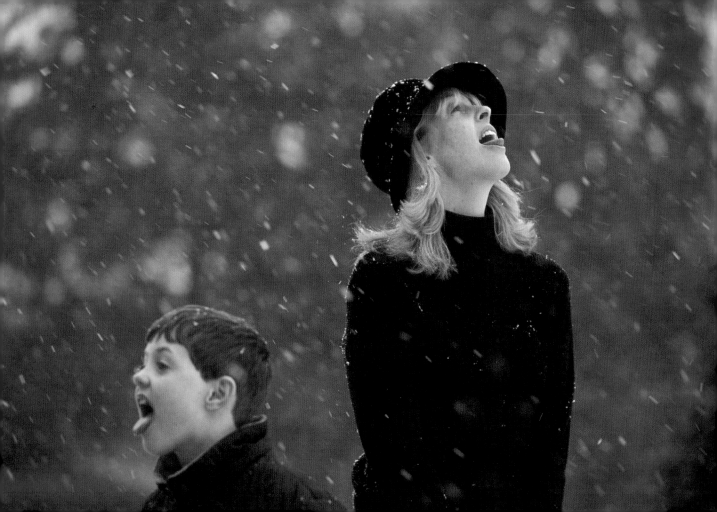

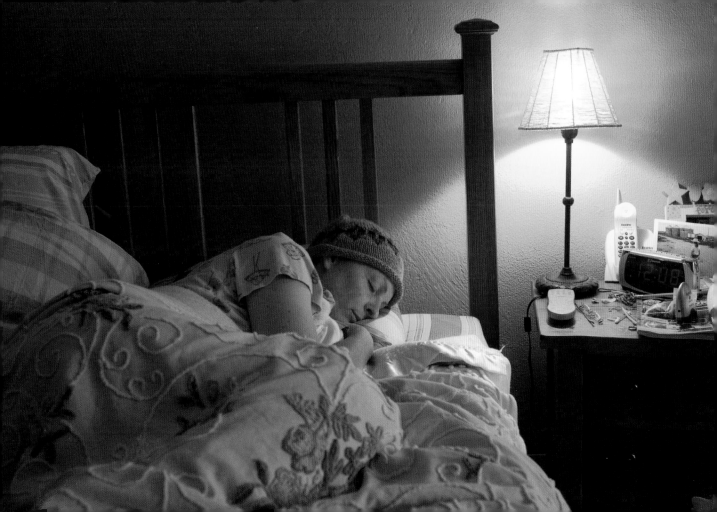

treating cancer patients a long time. We know he just doesn't know, isn't sure, and in his eyes I see *his* worries. He carries our burden, too.

Now, forgive me for saying this, but cancer can also be a blessing. An amazing experience that forces us to make amends, to set things right.

For example, cancer made me a better father. My work had made me a stranger to my three kids. They got along just fine without me. I was so bad that once I tried to get Kathy's midwife to induce labor just to get me back out on the road the next day.

But now we've changed for good. We appreciate what we have instead of lamenting what we don't. A new life and a new way of seeing, all from one malicious lump.

On our drives home from the doctor, I'd often look around at stoplights. I'd see people talking on their cell phones, putting on makeup, eating. They're all in a hurry. It seems so important.

But is it?

Down, but not out, from chemotherapy.

The road back:
Recovering from
treatment for
breast cancer.

In the end, each of us has so little time. We have less of it than we can possibly imagine. And even though it turns out that Kathy's cancer has not spread, and her prognosis is good, we try to make it all count now, appreciating every part of every day.

Sometimes we sit together on our porch at sunset. We don't talk much. We just hold hands. We listen to the crickets chirp, soft and cautious, as if they know that first frost might come tonight. We stay a while, until the last of the light is gone, until we can't see anything, until we're just two hearts in the darkness. We're in no hurry at all.

. . . until the last of the light is gone, until we can't see anything, until we're just two hearts in the darkness.

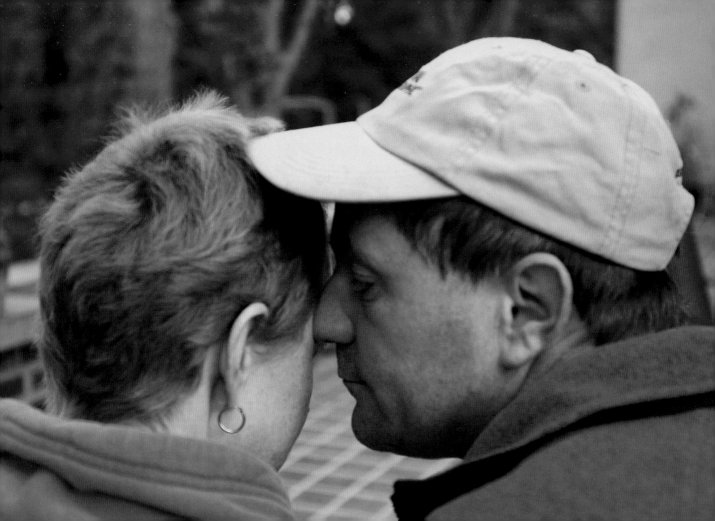

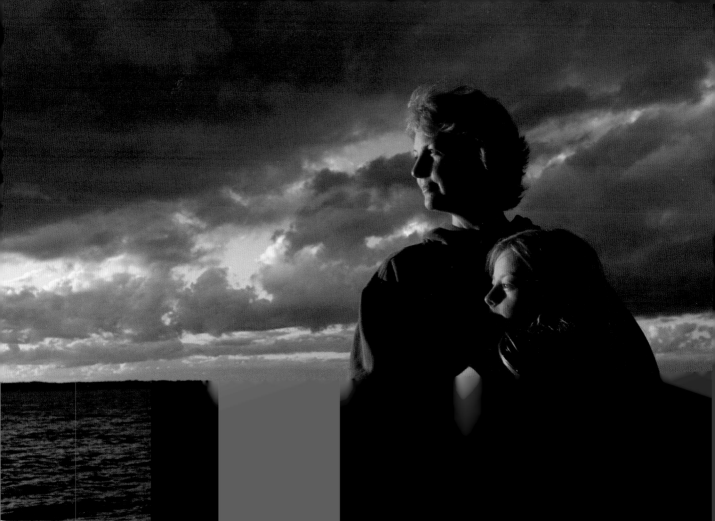

Mother's Day May 2008

To be perfectly honest, I'd never put much thought into Mother's Day. First, I'm a guy, and second, it was always just something I took care of with a call to the florist and a credit card.

But then something happened.

It was late when I got home. The room was mostly dark, but a hallway light shone on two figures, a mother and child, wound tight and close. They seemed small, lost in an ocean of blankets and pillows, as if in a raft at sea, clinging together for comfort and warmth. I could barely see, but I could *hear* something, so I sat down on a chair and listened.

Sunset on Leech
Lake, Minnesota.

35

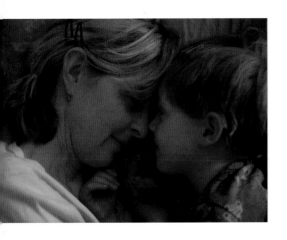

A song had lured me in, as soft and reverent as a whisper in church. It was the most beautiful thing I'd ever heard. It spoke of protection, affection, pride, and unconditional love. It didn't last long, but it made me tear up. And the child, well, he fell right to sleep.

I've since learned that the song was "Baby Mine," an old Disney tune. Listening in the darkness, I couldn't help thinking that if enough people knew it, we'd eventually vanquish the world's cruelty and hatred and pettiness.

All of us were perfect the moment we were born. We grow less so as the years go on.

But we'll always be somebody's child, with the memories of lullabies from long ago to prove it. Deep down, we know that getting to paradise isn't complicated. It's as simple as drifting off to sleep with someone you love.

And so it is with this song, sung by my wife, in the small hours, to her little boy.

Surely, *this* is Mother's Day.

Ultimate comfort:
Your mother singing
you to sleep.

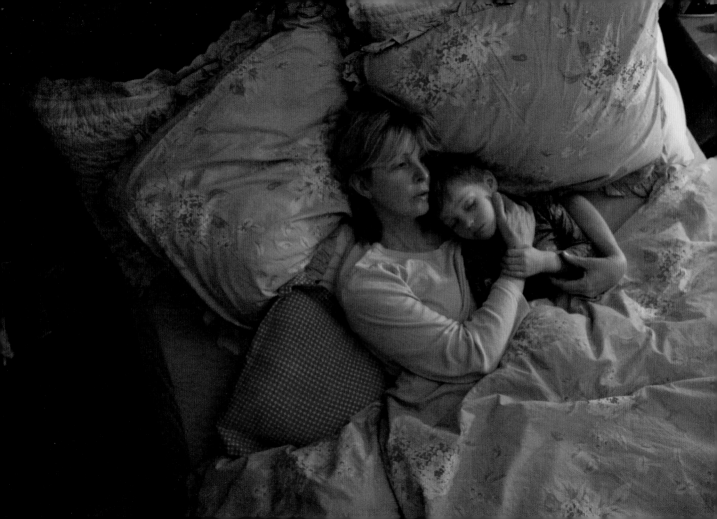

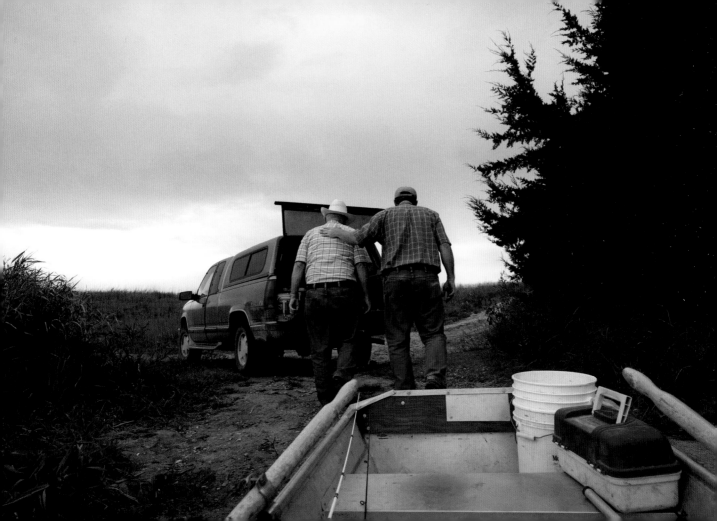

A Different World October 2008

My father turned eighty recently. How could that be? It seems like yesterday that this man had jet-black hair. He was a chemist who for thirty years drove the same two-lane road to a plant just three miles from home. He didn't complain or even talk about his job. It was steady, and that was good enough. Often he'd return with a sack full of steaks and a six-pack of Schlitz, ready to grill out and settle in with the paper. Lawrence Welk provided the background music.

You left work at the office back then. In the 1960s and '70s, there was no such thing as a boss who called you at home, let alone paged or e-mailed or sent you texts. Weekends were for bass fishing in the summer or pheasant hunting in the

Helping Dad back to the truck after an evening of fishing.

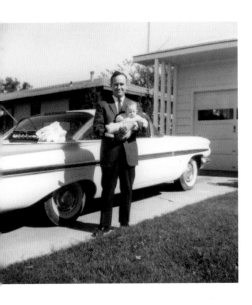

winter. Between seasons, we worked on the house or the lawn or the car. It was truly that simple.

Since his retirement, the world has sped up. Our velocity has increased, but the quality of life has not. For the majority of us today, there's no such thing as a real vacation. We've got to be on call every minute, or else. We live in a state of constant panic and emergency.

But here on Dad's porch, time stands still. He sits, screened in, content and comfortable with no bugs and plenty of heating and air conditioning waiting just inside. He remembers the discomfort of the Great Depression, knows it could come again, and thinks everyone should have gone through it. He's probably right.

And so, for his eightieth year, we had a party for him. His friends are largely gone now, so it was mostly family. His only brother flew in. To keep things light, we lit his candles with a blowtorch. His gag gift was a used chainsaw, the same one I'd borrowed from him ten years earlier.

At the end of the night, we gave him a new National Geographic

OPPOSITE: My dad, John Sartore, holds me at our first home in Ponca City, Oklahoma. Photo by my mother, Sharon.

RIGHT: Trout fishing in Idaho, 1962. Photo by my uncle, Gene Sartore.

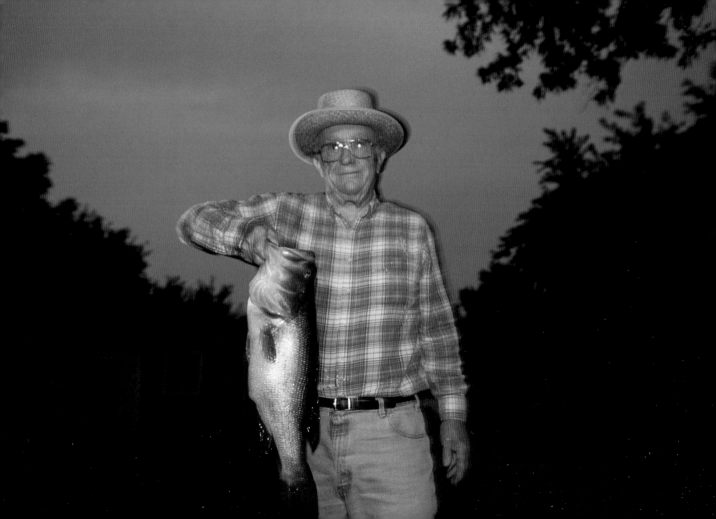

book on paradise. Inside was a picture I took of him holding one of the biggest bass he'd ever caught.

My father and I had the best times of our lives when we were fishing together. Farm ponds, mainly. We never saw anyone else out there. It was just him and me in our little rowboat. We took turns at the oars. We twitched top-water plugs and watched wild turkey and deer roam along the banks. The air was thick and buggy and smelled like steamed leaves. Afterward, we fried fish and eggs in real butter. The phone never rang. We slept until it was time to fish again, content and satisfied in every way.

Today the hair on his temples is the color of a late-winter snow. I tie on all of his lures now, and I row the boat. When we're done, I help him get out of the boat, get him back to the truck, help with the seat belt. I explain again that I've safely stowed his fishing poles, that we're now headed home, and, yes, we'll go fishing again real soon. On the drive back he talks of how it was, and how it could be again, if only we'd all slow down.

I want to be like him: honest, caring, and thoughtful.

Hopefully I'll have eighty years to get it right.

John Sartore with a six-pound bass in Arma, Kansas, in 2002.

43

Photographing Family October 2008

I've been to some of the toughest places on Earth for *National Geographic* to photograph the biggest, baddest beasts you can imagine. I've had polar bears claw to get into my truck, been charged by musk oxen and had jaguars snarl at me. But you wanna know my worst nightmare?

Baby photography.

Oh man, they're bad. I mean, they're the worst subjects ever invented. Period.

Why?

When the going gets tough, the tough take pictures.

44

Because little kids never, ever hold still. And there's all that fussing and crawling and crying.

But I've had to document my own offspring on occasion, no matter how nasty they've been. So let me share with you a few shortcuts I've come up with over the years.

First and foremost, photograph them while they're asleep. This seems so obvious, but it's true. You don't have to listen to them when they're out cold, and you get lots of time for composition too. They look so angelic. I guess you can lie with a camera after all.

Now if they happen to be awake and screaming, shoot that too. Why bore your neighbors with standard-issue baby pictures? Just look at that kid wail! And isn't it high time we put the drama back into baby photography?

But before I bag on babies too much, let me just say that older kids are really awful to shoot as well. Take mine, for example:

First there's Cole. Oh sure, he started out small and cute, but at fourteen he's taller than me, which is irritating, and he

Mothers can ignore their children's bad behavior because they see so much of it.

47

has this HUGE fit every time I want to shoot him. Somebody should teach that boy some manners.

Next is Ellen. She didn't start out as cute but held still better, so I photographed her more. The camera has sharpened her acting skills over the years by the way. She's really a pro, producing any emotion on cue—real tears even. But she needs constant pay-offs for motivation, mainly in the form of ice cream.

Finally there's Spencer, simply a bad seed who won't hold still. He's started to take candy bribes, but the minute I bring my camera up to my face he yells, "Done!" and runs away. He's smarter than he looks, unfortunately.

Even our dog, Muldoon, is impossible. Oh, I get glimpses of him around the house, but it's mainly as he steals food off the counters, and he runs off faster than Spencer. You would not believe what I find buried in my couch.

So this is my struggle. With 24/7 access, in theory these should be the best pictures I've ever taken. But the reality is, sometimes life gets in the way.

Some kids specialize
in throwing public fits.

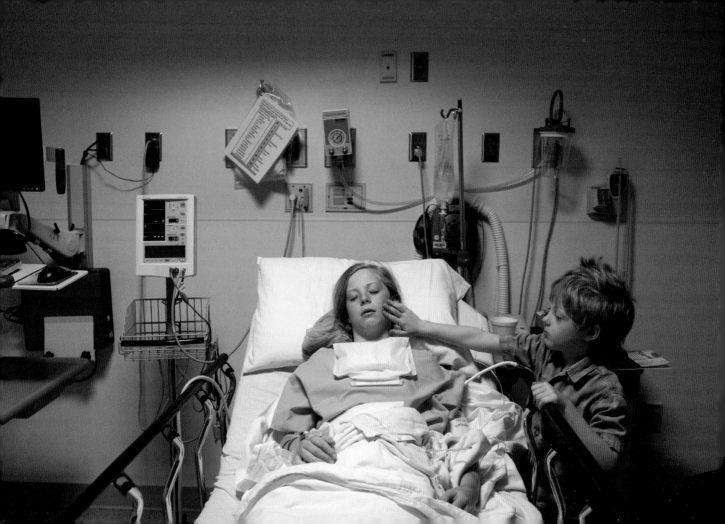

So take my advice; be discriminating. Not everything that your loved ones do is interesting or worthy of preserving for all time. Why torture them for nothing?

In case you forget any of this, I've put it all into a book—something to think about at least.

But hurry up, okay?

Ellen just had her tonsils out, and that ain't cheap.

Brother Spencer checks out his sister, still out cold after a tonsillectomy

First and foremost, photograph them while they're asleep.

I've Got a Problem September 2008

Ever drive by an abandoned house and think how fun it would be to restore it?

Here's a tip: Keep driving.

My wife, Kathy, and I are restoring our fourth such old house now. It's been a living hell.

First came the airplane bungalow in Wichita. On day one, I fed a two-by-four the wrong way into a table saw and blew a hole through the front door. I next hooked a toilet up to hot water—a wasteful accident, but it was winter, after all, and for a while we felt like royalty.

Which is worse? Painting an old farmhouse this way, or buying it in the first place?

52

The finale on that house was when I completed an electrical circuit using the kitchen sink. We got shocked every time we washed up for dinner.

Next came the two-story stucco in Lincoln. Kathy bought it when I was too far away to stop her. From a moldy pay phone in the Amazon, I yelled, "You can't do that!"

"Yes I can," she laughed. "You gave me power of attorney last year." As consolation she faxed me a drawing of a stick house that said, "Trust Me."

Then there was the 1895 Victorian farmstead. It came with a chicken house, a pair of barns, and twenty acres, which need constant mowing. What it didn't come with was heating, real wiring, or plumbing.

We took the interior apart—numbering the pieces and fighting as we went along. Such sweet memories. During one argument, Kathy intentionally dropped a four-by-eight sheet of drywall on my head. And then there was the night I found a wall of water pouring from the living room ceiling. I just

Historic home restoration is very fun and satisfying.

OPPOSITE: The Sartores, down home on the farm near Dunbar, Nebraska.

BELOW: By accident, I once hooked up the toilets to hot water.

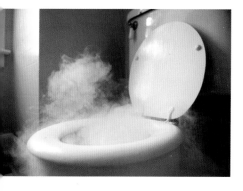

turned off the light and went back to bed. At that point I literally hated every inch of the place.

Five years and a hundred thousand dollars later, we got it listed on the National Register of Historic Places. That's a mighty expensive plaque.

Which brings me to our present house, the 1922 Money Pit. A once-grand estate, it came with an indoor swimming pool, bowling alley, and call buzzers for the maids, none of which have worked in fifty years. We've worked plenty—nonstop roofing, painting, grading the yard, you name it—for ten years now. And we're still not done.

And though we got this one on the National Register too, this plaque will cost us double what the farmhouse did.

So was it all worth it?

I don't know, but we just bought another one.

Ask me in twenty years.

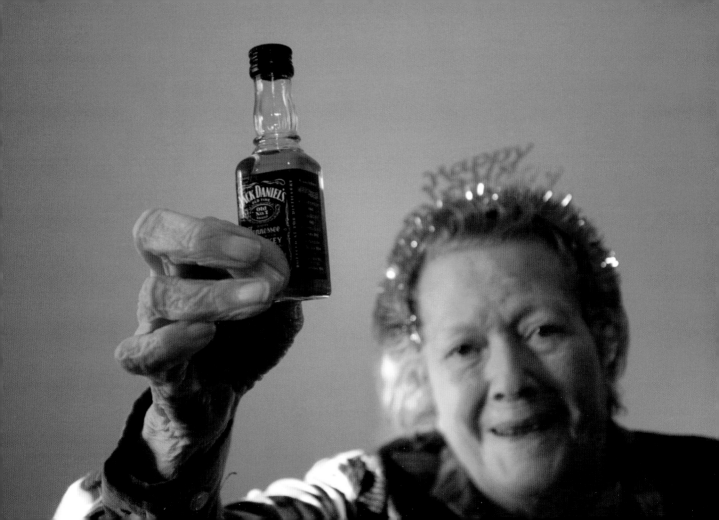

Laughter Is the Best Medicine October 2007

My grandmother was a tough old bird.

Her name was Faynell Meese. Her first name was completely made up by her five-year-old brother, Volney, whose name was also completely made up.

She had a lot of sayings: Sing before breakfast, cry before supper. Marry in haste, repent at leisure. And my personal favorite: When poverty walks in the door, love flies out the window.

She died this year, at the age of ninety-one. This surprised us all. We never thought she was gonna go. She laughed too much.

We snuck some Jack Daniels into my grandmother's ninetieth birthday party.

You see, her favorite saying of all was "Laughter is the best medicine." She believed that it kept her young, kept her feeling as good as possible, kept her alive. She said that laughter, and the well of happiness it's drawn from, is the root cause of good health, and that a smile is actually good for you.

I have no reason to doubt that. In fact, I believe it with all my heart.

For example, years ago I had a splitting headache and an episode of *Seinfeld* came on. I laughed through the entire show, and thirty minutes later, my headache had completely melted away. I've been sold ever since.

Studies have shown that laughter causes relaxation, relieves depression, and provides pain relief. It also lowers blood pressure, increases brain function, and bolsters the immune system, which fights infection, even cancer. So it's not only a tonic; it's a lifesaver.

Silliness counts too. Halloween is perfect for this. It's just fun, and it doesn't make a lot of sense. Or take the Chicken Show

Named for their fabulous tans, the Boston Brownies goof off at their beachside club.

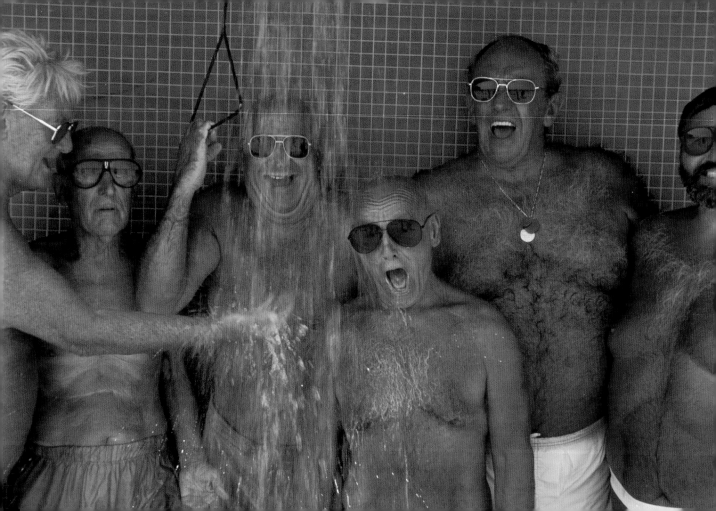

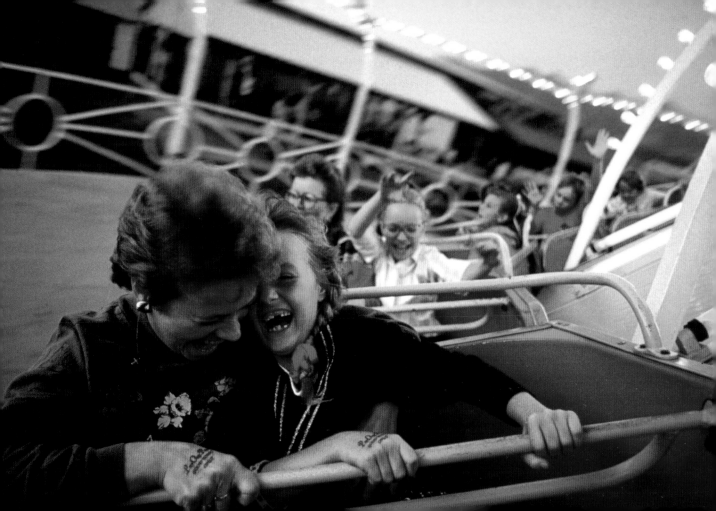

in Wayne, Nebraska. It's three days of all things chicken and egg, and I've never laughed so much. Parades are the same way. Smiling and waving—whether at a Rodeo Queen in Nebraska or Miss Top of the World in Alaska—is great for what ails you.

And don't forget to take to take it to work. You can't wait until you retire or hit some magic date in the future before you start enjoying yourself. You're liable to be dead by then because you didn't smile enough. Do it right now, because now is all you've got.

Cowboys seem to know this instinctively. Dogs and little kids too, but that's probably because they don't have to go to work. I've even got a friend who trains bears for a living who is constantly laughing, even when his bears look like they're mauling him. I'm sure he'll live to be a hundred, if a bear doesn't get him first.

So what is laughter anyway? A medical book might describe it as a series of convulsions or spasms brought on by humor. That tells me nothing. I know it's much deeper than that.

Fun at the Lemhi
County Fair in Idaho.

The Chickendale Dancers
in Wayne, Nebraska.
They're not quite as fit as
the Chippendales.

I believe that laughter sustains happiness, even when there's nothing to be happy about. It just makes me feel good, and that ain't bad.

Maybe in the end, then, it is simply this: Laughter is the sound of pure joy.

Now that's a saying even a grandmother could love.

I believe that
laughter sustains
happiness . . .

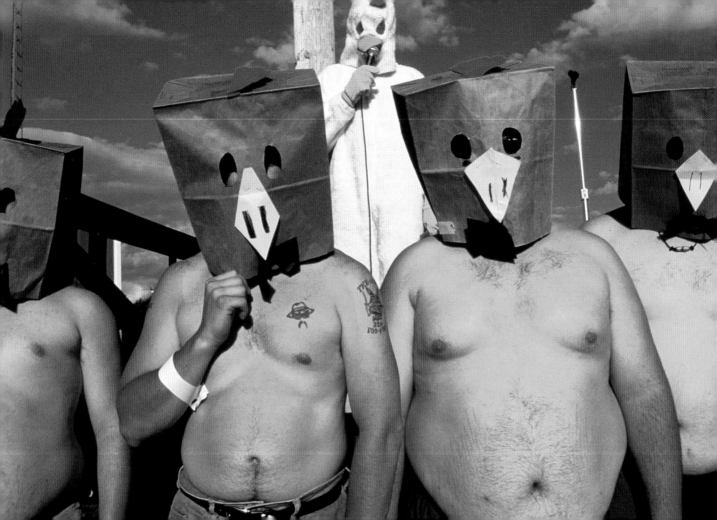

Mud March 2006

I've got a nine-year-old daughter who delights in shining my shoes. The fact that I pay her a dollar a pair might have something to do with it. The Tooth Fairy only whetted her appetite with that quarter last week. She's hungry for more.

It's a good thing, too, because the mud is almost here.

Now I'm not talking about the disaster mud you see on the evening news. I'm talking farm mud, nasty and deep and eager to dominate our lives not only here in rural Nebraska but on every farm and ranch from coast to coast.

Herding livestock is pure misery: a cold, sloppy battleground

Be afraid, be very afraid.

67

complete with thousand-yard stares and county-wide front lines. The cattle and sheep don't like it any better than the ranchers.

And pigs? They're coated in much more than mud, if you know what I mean.

Dirt roads reel in the foolish. We don't trust them in the springtime. It's no wonder we've paved over our cities to the point of sterility. Mud implies a loss of control, indeed a loss of civilization itself. We're not taking any chances.

Mud makes us uneasy, like the Earth is getting back at us for all those wounds. Plowed, barren fields erode terribly. Virgin prairies don't. Mud doesn't occur in places that have been left alone.

But I don't curse the mud. I just think of it as the glue that binds winter to summer. It holds the promise of spring. Why should flowers get all the glory?

I know a few others who don't mind the mud either. In June they play mud volleyball out at the county fairgrounds. It's really decadent, with people getting just as dirty as possible, on purpose. I don't think they even keep score.

Getting muddy, on purpose,
for a volleyball game
near Ogallala, Nebraska.

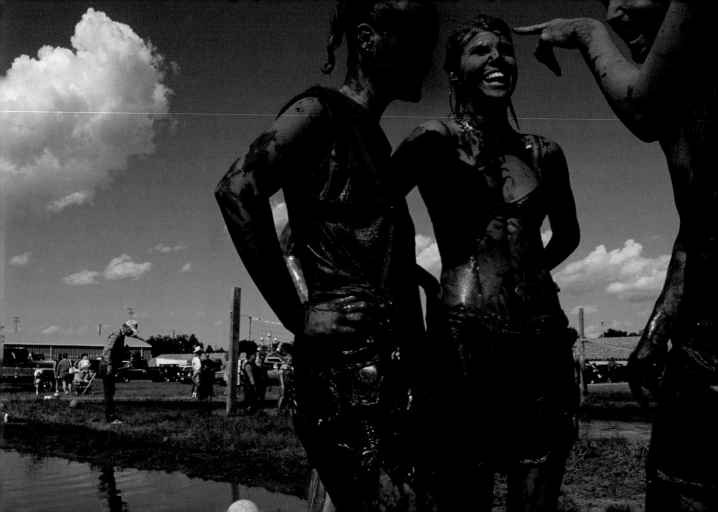

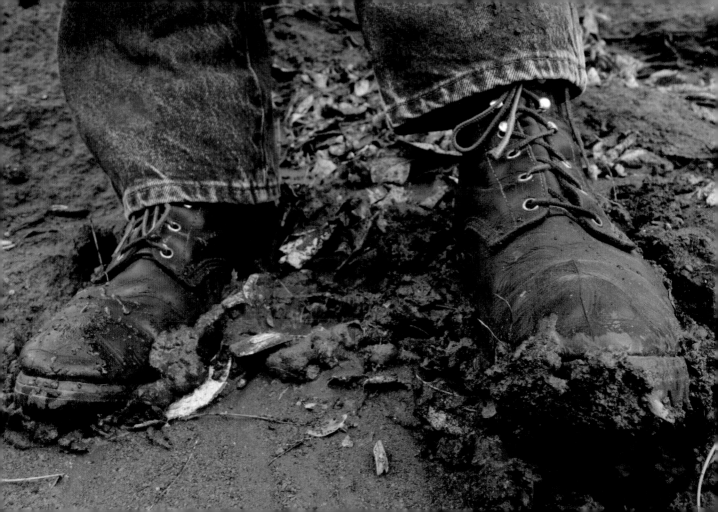

Maybe mud is all in how you look at it. Come to think of it, the only time I really sit still anymore is when I've got some serious boot cleaning to do. I get out my Swiss army knife and work over one sole at a time. It forces me to slow down, take my mind out of high gear for a few minutes. I listen to the birds and feel the sun on the back of my neck. Some people would pay good money to feel this relaxed.

When I'm all done with the rough work, I take my boots back to the shoe-shine daughter with the missing-tooth smile. She's giddy about that dollar she's about to make, and I promise her one thing: I'll gladly get muddy again tomorrow.

Mud, a sure sign of spring.

I just think of it as the glue that binds winter to summer.

Summer July 2006

So where to start? There are many fine aspects to the season that I could mention, from the Fourth of July to swimming to snake hunts. And what about all those cardboard beer girls popping up at convenience stores?

Ah, summer.

But to tell you the truth, I'm into summer for just one thing: the thunderstorms.

You haven't lived until you've experienced a real thunderstorm. When done just right, these things grow forty thousand feet tall before flattening off in the stratosphere. You can see that anvil from a hundred miles away.

What would summer vacation be without a sister ignoring her little brother?

On many hot days, the clouds first appear around lunchtime, storybook innocent, pretty, puffy, and white. But if conditions allow, these clouds gather force, and you get what the weathercasters excitedly call a supercell, capable of violent winds, torrential rains, or . . . nothing at all. Only the storm knows what it will do.

For a photojournalist like me, these are the glory days.

In the late-day distance, thunderstorms are stunning, alive and boiling orange, changing as you watch them. Bumpy mammatus clouds hang off their undersides, like bats waiting for nightfall.

These massive clouds promise rain that you can smell forty miles before it arrives. It's all so menacing, with a heart as dark and deep and blue as a bruise. The birds go quiet. Everything falls calm and silent and still.

But not for long.

Suddenly a wall of wind and rain hits, and you can't see anything at all. The air is charged with lightning and explosions

An approaching thunderstorm means fishing is over for the night on Leech Lake, Minnesota.

and danger. And then it's over—and we've gone from day to night to day again in about an hour.

Alive as they are, thunderstorms make us feel alive, too. Out here on the Great Plains, we respect and appreciate that. It's a long time between thrills.

And when the storm season finally comes to an end, we know that shy, sensible fall is coming. And soon enough, indifferent winter. Then what will we do for fun?

Just wait 'til next year. It'll be better than ever.

A hailstorm at harvest
time. Haysville, Kansas.

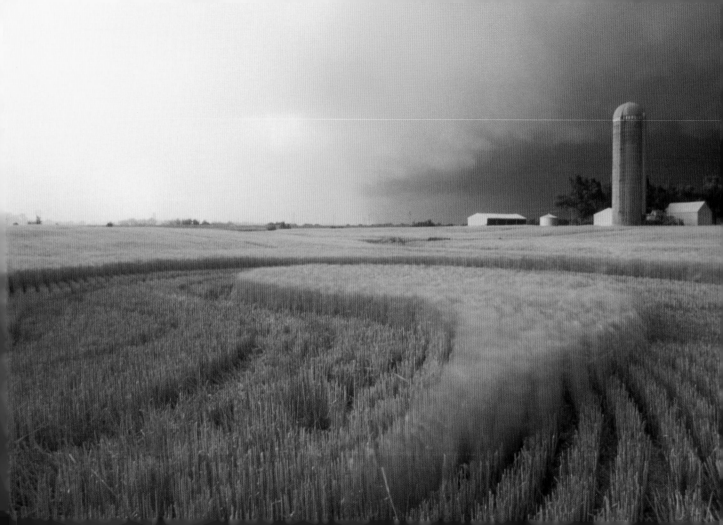

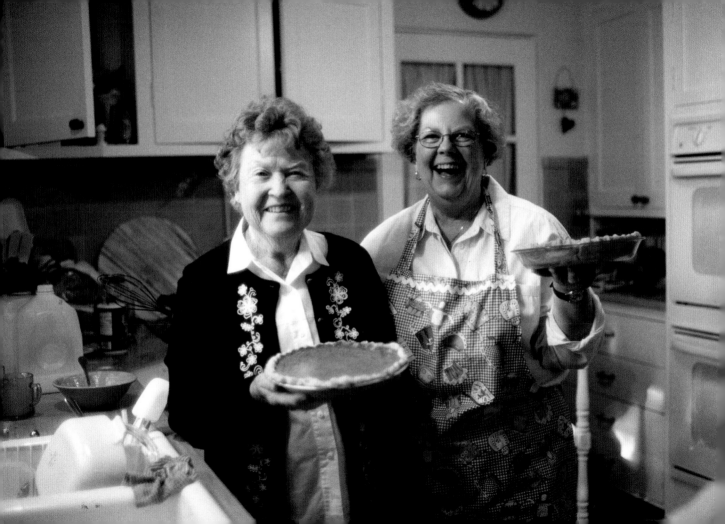

I'm from Nebraska.

It's a pleasant place, really.

People wave as you pass them on the highway. Nobody honks if you're late coming off a green light. They still know how to make great pies, from scratch. Even the crust.

Most importantly though, they know how to grow things.

As individuals, we've never been as removed from the land as we are today. We think we get our food from the grocery store, but in reality it's the result of men and women struggling with

Two moms, two pies.

debt and weather and nerves to control a landscape so vast it boggles the mind.

And control it they do. Why the milo's so good they're literally piling it up on Main Street! Thomas Hart Benton would be right at home here.

Now I've been around some—*National Geographic* has seen to that. I've photographed oranges in California, peppers in Louisiana, peas in the Palouse.

But each fall I make sure I'm back home again. It's the best time of all, the payoff for the extreme cold, mud, and heat of the other three seasons. Prairie grasses mimic the setting sun, fading from gold to cinnamon in color. Football begins. Combines bring home smiling men, late at night, anxious to wake their wives with news the last field just made hundred bushel corn.

At Thanksgiving we take full measure of this land of ours. Wheat and pork, beef and beans, they all pay off at once, it seems. And though most of us are not on the land anymore, we can still touch the Earth on this one special day.

Too young to drive a combine, a young boy waits in a wheat field near Oxford, Nebraska.

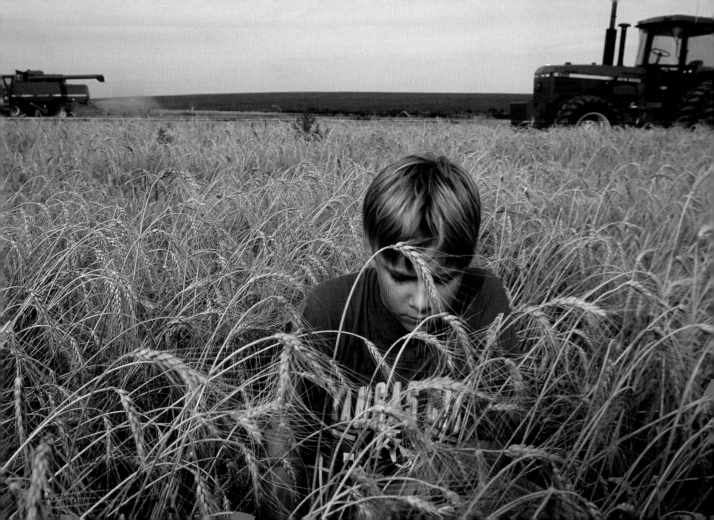

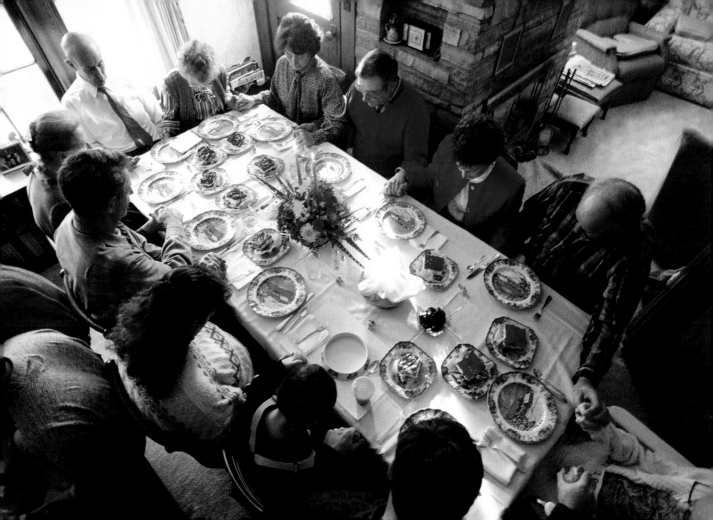

With pheasant-feather centerpieces and in our best clothes, we hold hands, look down, and offer up a prayer. It's a long one, running the gamut from health and happiness to the dearly departed. We pray next year will be even more abundant, bringing with it better prices and better yields, and we pray that the hail and grasshoppers and frost won't come. We know what it takes to keep the world fed.

We pause after this prayer; there is redemption in it for all of us.

And we can't help but smile.

The Thanksgiving prayer
at the Trumble home.
Papillion, Nebraska.

. . . we've never
been as removed
from the land
as we are today.

Kitchen Wars November 2010

For those of you who provide wholesome, nutritious meals for your loved ones, I say, "Good for you."

But if you want a taste of the real world, come over to my place, where every day it's hand-to-hand combat.

If I'm cooking, it's omelets, containing anything that hasn't gone bad yet. This can be dicey—it's a minefield inside my fridge.

My wife, on the other hand, specializes in the frozen meatballs from the local big box warehouse. They come in a sack

"This ain't a restaurant," says Kathy.

84

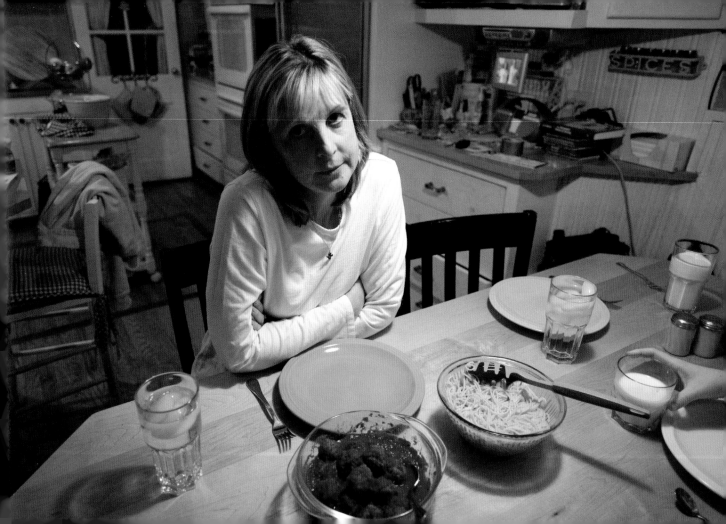

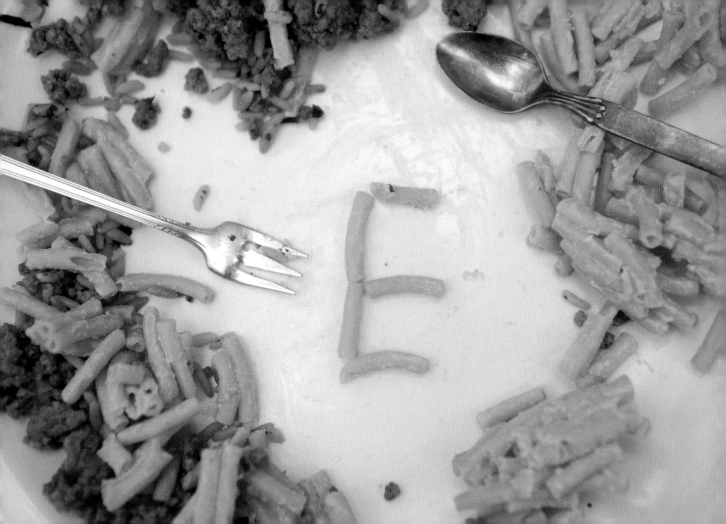

as big as a dog food bag. When poured into a bowl, they even sound like dog food. Three minutes in the microwave, some spaghetti, and the show's over. "This ain't a restaurant," she deadpans.

Next there's Cole, the oldest. He's nearly seventeen and eats mainly cardboard pizzas, usually after midnight. For a while he was happy devouring the pizzas that cost just ninety-nine cents. Now he only inhales the upscale kind, with lots of toppings, that cost five bucks each. That really hurts.

We also have daughter Ellen. She's picky and will only eat with a tiny fork and spoon. Of course she doesn't really eat but pushes her food around and around her plate, as if she's herding cats, eventually making the letter E.

Maybe it's all that sugar she eats. Every year on Halloween she ends up moaning on the floor with a stomachache. I used her sweet tooth to my advantage once, trading her a candy dinner in exchange for a promise that she'd never get a tattoo. Though she was only seven at the time, I expect her to stick to her end of the bargain.

Daughter Ellen is an expert at playing with her food.

Then there's Spencer. He's gone truly feral. I hid with a camera in the corner of the kitchen to get photos. Turns out he climbs the cabinets like a squirrel monkey when we're not looking. Quite agile and wary, he spooks easily, but I learned he's partial to Fruit Roll-ups and chicken-flavored bouillon. Go figure.

And any day now, I'll try to trade him a half gallon of cookie dough ice cream for the promise that he'll never, ever start smoking.

Now that's my idea of healthy eating.

Son Spencer forages
high in the cabinets.

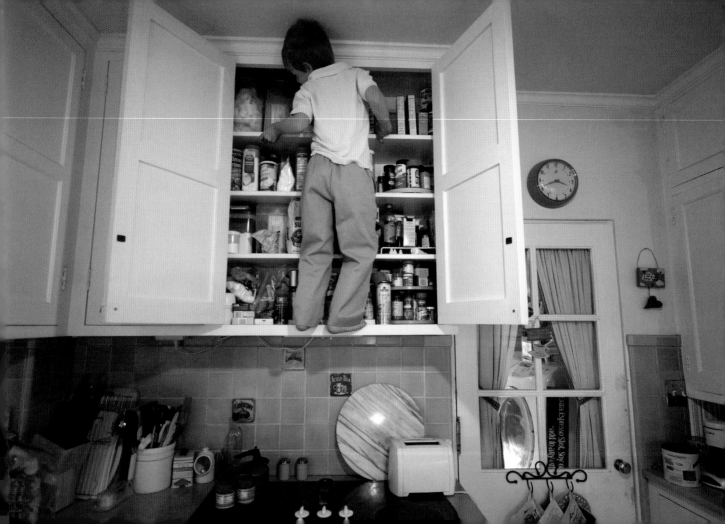

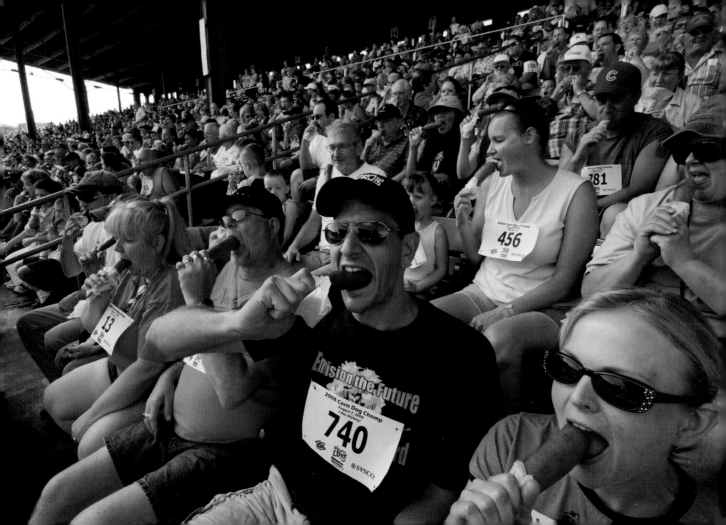

Fair Food October 2010

I used to think that the worst-sounding recipe ever was my mother's very-dramatic-yet-deadly-serious directions for her seven-layer salad. I quote: "Starting at the bottom, you want your veggies, sugar, and about a quart of Miracle Whip. Spread that Miracle Whip clear to the edges to keep the air out. You don't want your veggies going limp. Sprinkle the top with shredded cheddar cheese and bacon bits. But you don't want your cheese too thick. You don't want to overpower the Miracle Whip. The cheese is just a garnish. Remember that."

Now that I've eaten my way through seven state fairs, however, I realize what a culinary piker she really is.

The world's largest corndog chomp—8,400 bitten at one time—at the Iowa State Fair.

91

Four full weeks of documenting fairs and their food for *National Geographic* will change your world, and not for the better. The fact that I ate nearly fifty corn dogs along the way didn't help much. By the end, I felt permanently sick to my stomach.

Let's start with Iowa, which actually opened their fair by setting a gastronomic Guinness record: 8,400 corn dogs chomped at the same time. Amazing what people will do to get in free.

After that came the Minnesota State Fair, where butter is not just for eating anymore. It's for carving the likenesses of live dairy princesses in a cold room.

There were cheese carvers at the Nebraska State Fair and a Spam cooking contest in Kansas. Green eggs and Spam? It pretty much tastes like it sounds.

But none of these venues—and I mean none of them—touched Texas. A cornie-dog eating contest led the parade in the hot Texas sun, complete with plastic barrels for those who "lose their way." Hungry for more? How about deep-fried Coca-cola?

A dairy princess
sculpted in butter.
Minnesota State Fair.

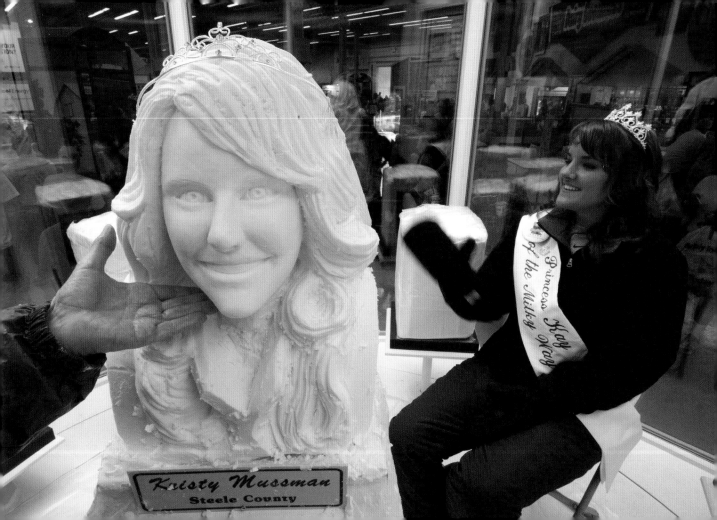

Kristy Mussman
Steele County

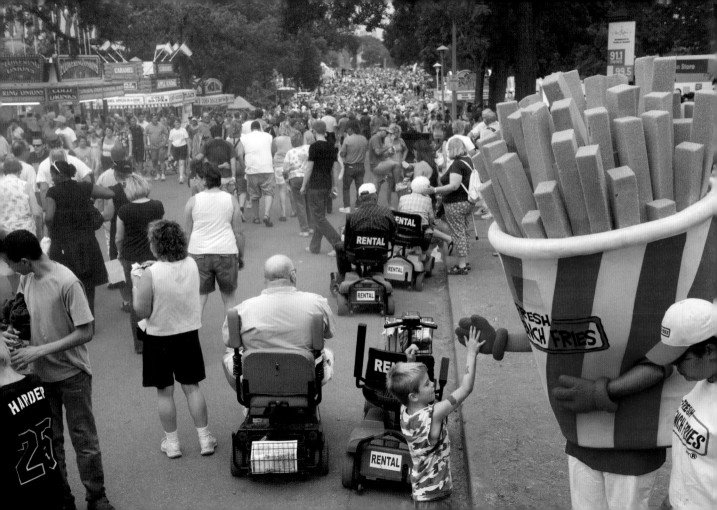

Now combine that with rides that spin really fast. The Horror. The Horror.

So why is every shred of culinary decency ignored at fairs? Because you only do it once a year, and everyone else is doing it too. It's kind of like Vegas, but with the occasional hog show thrown in.

Chicken-fried bacon anyone?

You want fries with that? A day at the Minnesota State Fair.

It's kind of like Vegas, but with the occasional hog show thrown in.

Ice Water February and March 2009

It takes a lot of work to visit the end of the Earth.

Two full days of flying, followed by three days on a ship through some of the roughest seas on the planet—all just to reach the very tip of the Antarctic Peninsula. It is terribly expensive and time-consuming, full of seasickness and bruises and sleepless nights, surrounded by steel-colored ice water that would kill you in ten minutes if it could.

And it is worth it.

Antarctica is so cold and remote that we humans haven't wrecked it yet. I saw no garbage in the water or on the beaches, no jet contrails in the sky. There are seldom any sounds other than wind, water, and ice.

Gentoo penguins on a mild summer day on the Antarctic Peninsula.

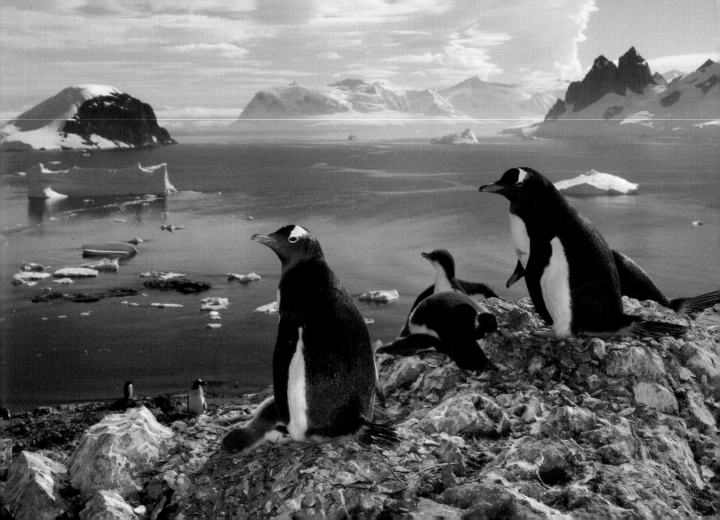

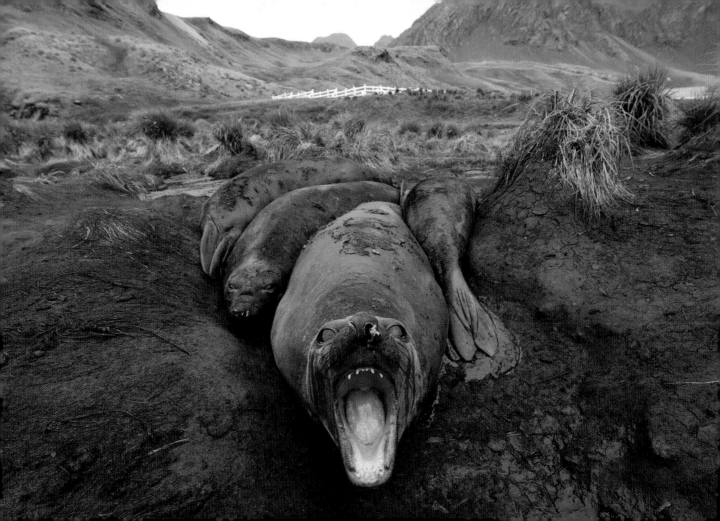

The "frozen continent" is larger than the United States. On average it's the windiest and coldest place on Earth. Katabatic winds roar out from the interior at one hundred miles per hour, and on a calm day the temperature can reach a hundred degrees below zero. It stays dark for months at a time.

But in those few months when the weather permits, it is truly amazing. By late February you can just catch the end of summer, and the place is teeming with life. Gentoo, macaroni, and Adélie penguins are rearing the last of their chicks, even though the very young won't make it. The storms will get increasingly worse from now on.

For now, there are seals everywhere, from crabeater to fur to leopard, finding their place in the sun. And whales like humpback and orca are there. All are feasting on blooms of tiny krill, the base of the ecosystem.

The scientists along the way told me two things: First, don't get climatology (the long-term study of climate change) confused with the short-term weather concerns of meteorology. Second, Antarctica has warmed, so far, by nine degrees since

An elephant seal blares
a warning to stay away
in South Georgia.

the industrial age began. This warming could affect the production of krill and all that depend on it, not to mention global weather systems and sea levels as all that ice melts. It's hard to remember that, though, when the all the views are epic.

On the way home I toured much of the Southern Ocean, seeing the Falkland Islands and South Georgia. The latter is home to some of the largest wildlife congregations anywhere.

It's an odd feeling to know the moment when you're witnessing the best thing you'll ever see in your lifetime. But here it is, sunrise over a king penguin rookery at St. Andrews Bay. There were a couple hundred thousand birds there, and none were scared of me. Stills and video don't do the place any justice at all.

In the end I sailed thousands of miles. There were no cell phones, no traffic jams. There was no dirty, greedy race through advertising and the price at the pump. No daily tally of bad news.

Our anxieties, indeed our entire economy, meant absolutely nothing. One thing's for sure: There is no finer sight than ice water in every direction.

The best thing I've ever seen was on South Georgia Island: No wind, beautiful light, and thousands of king penguins who were just fine with me being there.

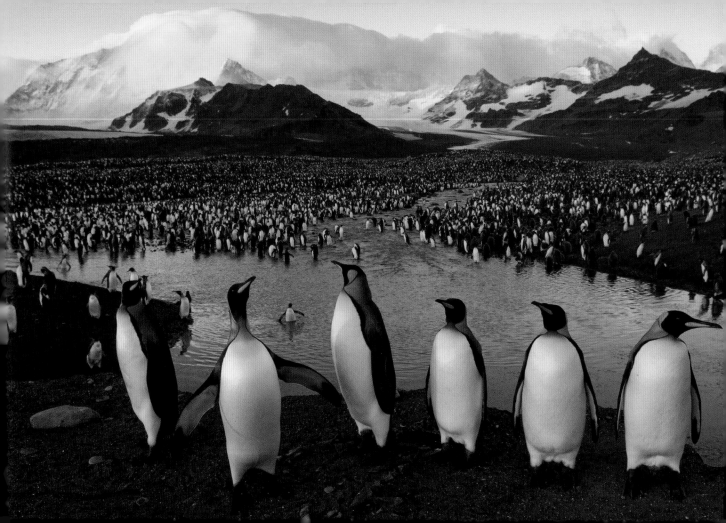

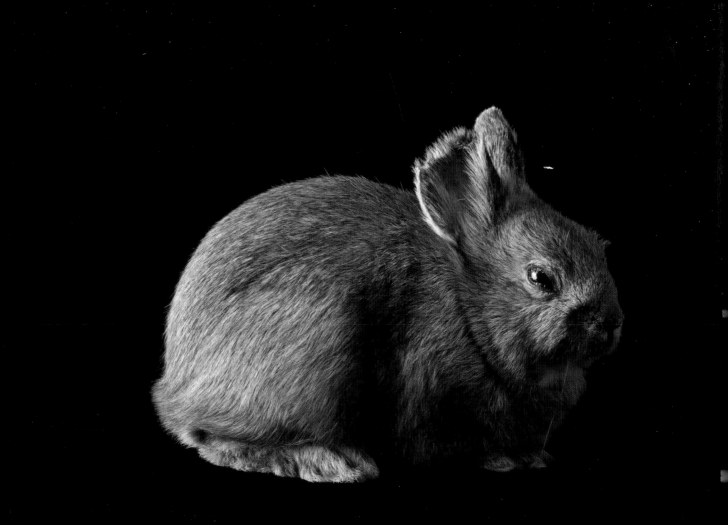

Endangered Species April 2010

You're looking at a Columbia Basin pygmy rabbit, one of the rarest mammals in the world. Or at least they were. They're now extinct.

By the time I got to this lone female, named Bryn, at the Oregon Zoo, it was already too late. Years of habitat loss to agriculture and a failed captive breeding program had led to this.

Nearly blind and with tattered ears, she was barely aware that I was taking her final portrait.

You know the saddest thing? This is only the beginning.

Columbia Basin
pygmy rabbit.

In a countdown of sorts, I come before you today as a witness, to speak of creatures, great and small. All are at risk of extinction.

With nearly seven billion humans on the planet, wild places and wildlife are running out of space and time. Oh, I know you're real busy, and that the topic is depressing, but this is worth your full attention. After all, it's folly to think that everything else can go away but that you'll be just fine.

It's a thankless job, really. Most folks don't want to know that this armadillo or that duck is endangered. In fact, the animals themselves don't often show much gratitude, let alone cooperate with me.

But I believe that all creatures, rare or common, have a basic right to exist. From the St. Andrew beach mouse to the Delhi Sands flower-loving fly. From the lesser prairie chicken to the black-capped vireo.

And the news is not all bad. When we've tried, we've saved things on the brink of the abyss. Just look at the black-footed ferret and the California condor. And let's not forget our national symbol, the bald eagle, which is in fine shape now.

A St. Andrew
beach mouse.

104

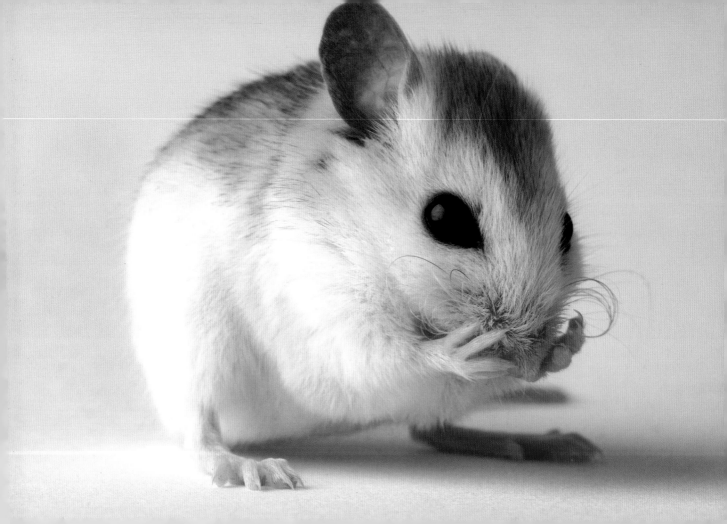

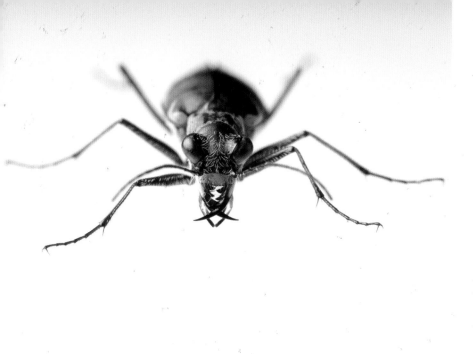

RIGHT: Lincoln, Nebraska's own Salt Creek tiger beetle continues to hover at the brink of extinction. Since endangered species belong to all Americans, why don't we establish a fund that pays willing landowners a premium for conservation easements that benefit such critters? Why not make endangered species profitable? Surely that would help to save them.

OPPOSITE: Proving we can do it if we only try, the California condor was saved from extinction through captive breeding programs.

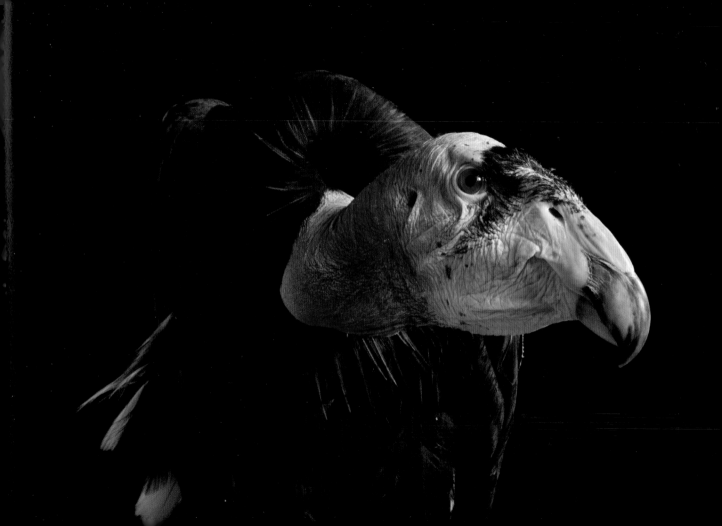

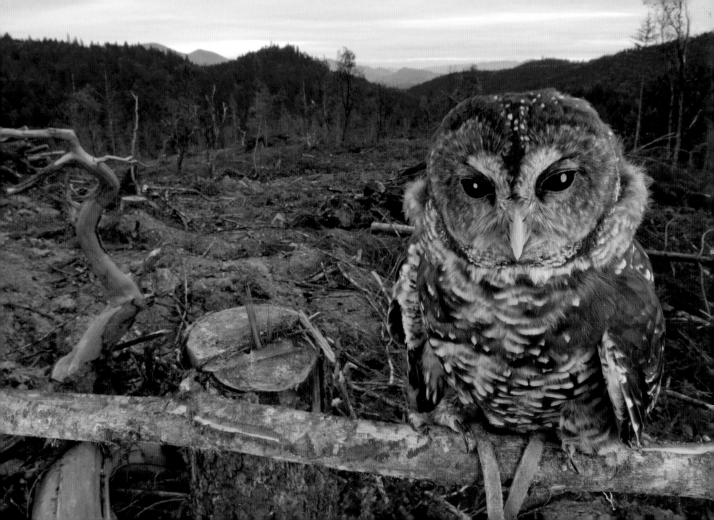

But the successes have been too few, and so the point of my photos is simple enough: to get you to notice—and get you to care—before it's too late.

Each endangered species sings a unique verse about its place in the world, but the chorus is the same: They're all in serious trouble. As animals ourselves, this should make us very nervous.

The northern spotted owl couldn't agree more.

A captive northern spotted owl in a clear-cut. Oregon.

Alaska's North Slope March 2006

I own an SUV, a pickup truck, and, just for fun, a 1961 Cadillac convertible. I think it gets the same mileage as a Hummer. I'm not proud of that, but man, it looks good. Each spring, I put on a bunny suit and drive it to a neighborhood Easter egg hunt. The kids love it.

So, first and foremost, know that I am a consumer of fossil fuels.

But I am also a photographer for *National Geographic* magazine, and recently I photographed what is shaping up to be a real mess.

For three months I documented the entire North Slope of

Shallow meltwater provides habitat for millions of ducks, geese, and shorebirds each summer on Alaska's North Slope.

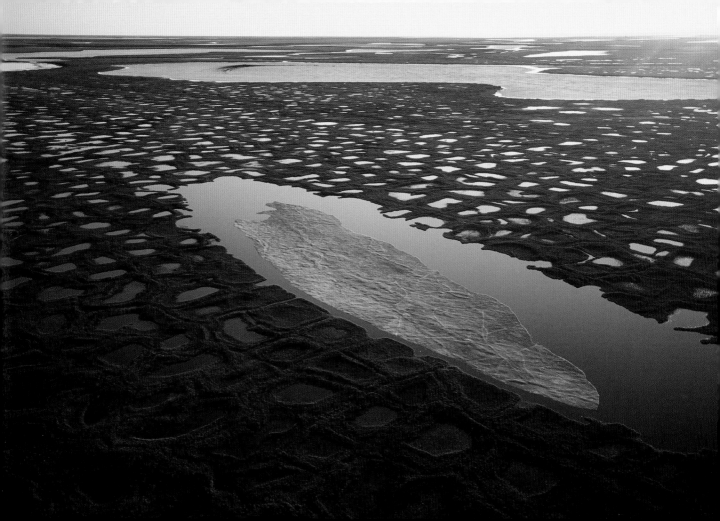

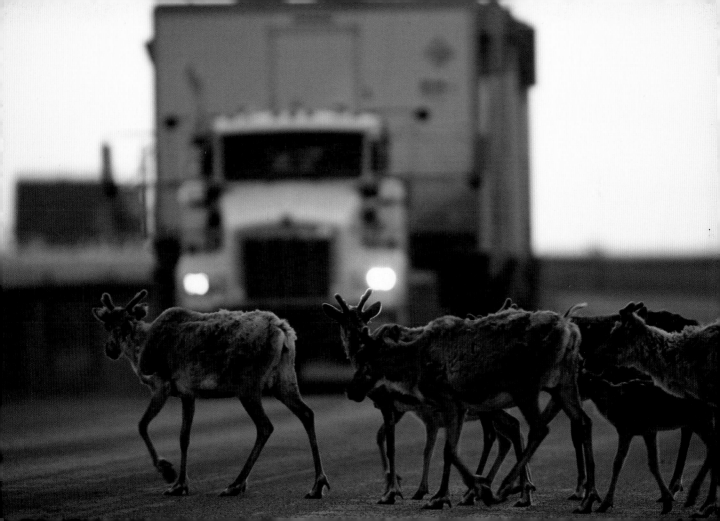

Alaska, from the Canadian border to the Chukchi Sea. And what I learned was very surprising.

See, everybody's been talking about ANWR, the Arctic National Wildlife Refuge. It's where the Porcupine caribou herd goes to calve each year. There might be oil under it or just offshore. It's ground zero for environmentalists. For years they've been desperately trying to keep the drillers out.

But while everyone has been distracted by that controversy, much of the Slope has been quietly leased out for oil and gas development. Here's why this matters:

The North Slope is, by far, the largest wilderness left on the continent. It contains immense wetlands that are critical to shorebirds, ducks, and geese. Peregrine falcons nest along the river bluffs. Beluga and bowhead whales migrate just offshore.

And then there's the Western Arctic caribou herd. It's several times bigger than the one in ANWR yet virtually unknown because it's been too remote to think about, until now.

Much of this wildlife lives in the National Petroleum Reserve-Alaska, or NPR-A. With a name like that, it's no wonder my own

Will you see some wildlife in an Alaskan oil field? Sure, but it's no longer a wilderness by any stretch of the imagination.

mother thinks we should drill there. But she hasn't seen the place yet. She will though. It's the cover story of the May issue.

Besides the beauty and grandeur up there, she'll see Prudhoe Bay, now one of the world's largest industrial zones, featuring thirty years of drilling and sprawl and pollution. Through the gas flares you can glimpse the future of the rest of the Slope, and it's not pretty.

Now that the price of gas is so high, energy producers are very motivated and are starting to spread out into the fragile wetlands in all directions, even though drilling it all won't do a whole lot toward reducing our dependence on anything in the long run.

It all gets me to thinking—what about increasing the fuel economy of our new cars and trucks? What about global warming? Go up to most anyone as they're pumping gas and ask them these questions. They'll look at you like you're crazy.

In the end, this is really a story that boils down to one question: What is the value of wilderness? Do we treasure anything beyond its worth in dollars and cents?

A polar bear on the carcass of a bowhead whale. Kaktovik, Alaska.

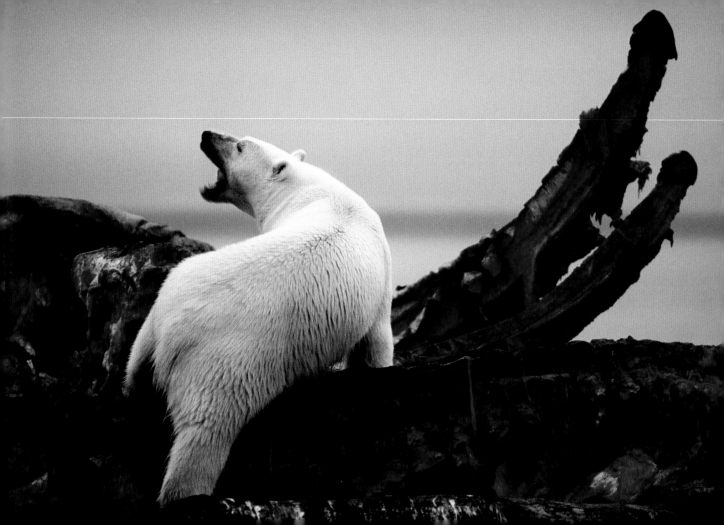

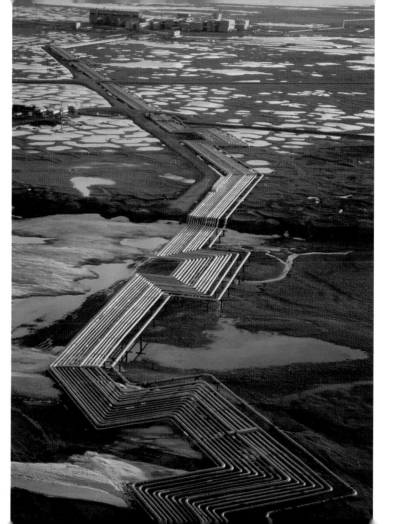

Do we treasure
anything beyond
its worth in
dollars and cents?

Basic human nature is driven by greed and fear and the fact that we're never satisfied. But the same qualities that have made us so successful as a species will also, I'm afraid, be our undoing.

Do we alter our behavior only when it's convenient? When money isn't on the line? If so, that day will never come. By saving places like the North Slope, we're actually saving ourselves. Big, intact ecosystems are critical for regulating our climate. They clean our water and our air. There's immense value in that, isn't there?

As a photojournalist, it's my job to simply shine a light. I point things out and let readers draw their own conclusions. Sure, I always hope they do the right thing, but it's not my job to tell readers what to think. I just want them to be aware of what's going on in the world. If they see my story and still don't care, well, we live in a democracy. I've done my part, and will abide by whatever the masses decide.

To my core I am an American—type-A, hyper, enthusiastic, and full of hope. I'll never live anywhere else. But after seeing what's happening on the North Slope, I have a very sinking feeling indeed.

Oil pipelines stretch
to the horizon.
Prudoe Bay, Alaska.

After the Spill July 2010

I recently went to my thirty-year high school reunion. When asked what I'd been up to, I said I'd been photographing the Deepwater Horizon oil spill. Without exception and without hesitation, my classmates started looking around for someone else to talk to. Oiled pelicans and blowout preventers were clearly not polite party talk.

The consequences of millions of gallons of crude oil pouring into the Gulf every day are hard to visualize. Picturing months of those consequences is nearly impossible. Slogans like "We're making this right" let us all feel better, but there are some real lessons waiting to be pulled up from that

Surface oil burns at the spill site, off the coast of southern Louisiana.

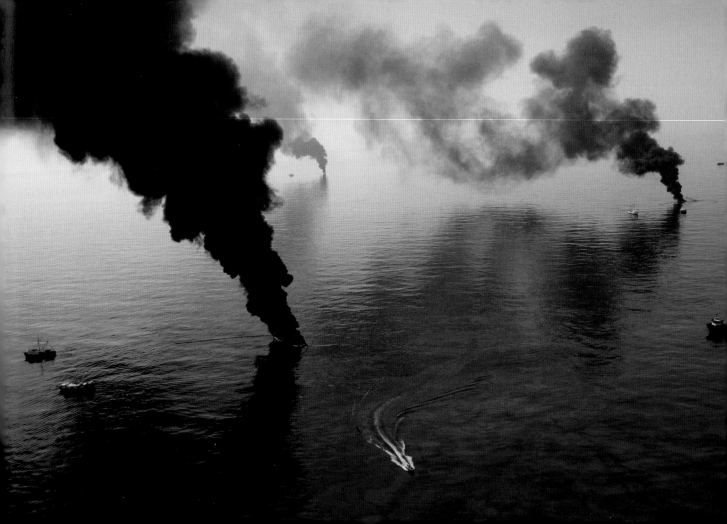

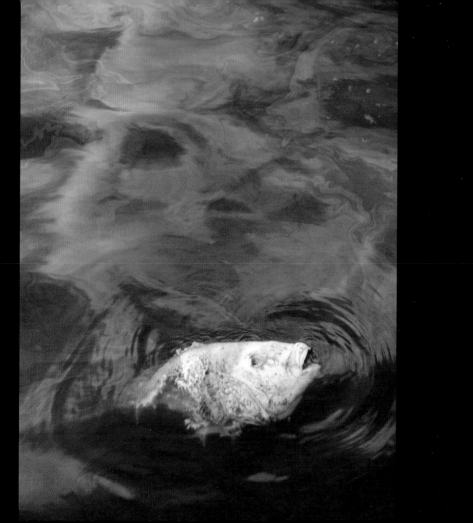

terrible brown ooze. Do we want to get our hands dirty? Judging by the Class of 1980, the answer is no.

We all want a comfortable life: Plenty of food, a house that's warm or cool enough, lots of distractions online or on TV. Oh, and cheap gas, that's important too. So much so that many vote for any politician who will promise it.

But is it cheap? Really? Sure doesn't look like it. For three weeks I saw firsthand the dead and dying birds, the coastlines fouled, the despondent fishermen, the trial and error of unprepared engineers, and the sinking of the oil with dispersants to hide it from ourselves. And for three weeks I had the overwhelming, awful feeling that our collective greed caused all of this.

When it comes to the dirty details of fossil fuel, we're often too busy or too lazy or too frightened to confront the truth. Besides, oil is complicated. Who knew the hazards of drilling for oil a mile down? We did. Will it happen again? Of course it will. But not in any way we might expect.

Once we get it, consider the end results of using it: emissions from millions of gas-powered cars, trucks, planes, power

A dead black drum in an oil slick off the Louisiana coast.

plants, lawnmowers, leaf blowers, and on and on and on. Too vast to worry about, right? We'll wage war for this stuff, but no details, please. Just keep the unleaded below three bucks a gallon and let's go for a drive.

Energy issues in general are hard to handle. High sulfur coal. Nuclear power. Solar power. Carbon footprint. Power from the wind. Cap and trade. Understanding any of it requires more than a distracted glance at a headline. There is no sound bite that will fix it, no painless magic bullet. Tackling this requires all of us pulling together and being passionate, informed, cooperative. That's tough to do in an age of national distraction.

So if a major catastrophe can't change us for the better, what can?

Money.

The Gulf spill didn't change much because the price at the pump didn't go up. There was no rush to buy smaller cars or limit how much we drove. But when we had five-dollar-a-gallon gas two summers ago, you would have thought the world was coming to an end. Every tick up or down was major news. You

Oil-fouled pelicans at a rookery near Grand Isle, Louisiana.

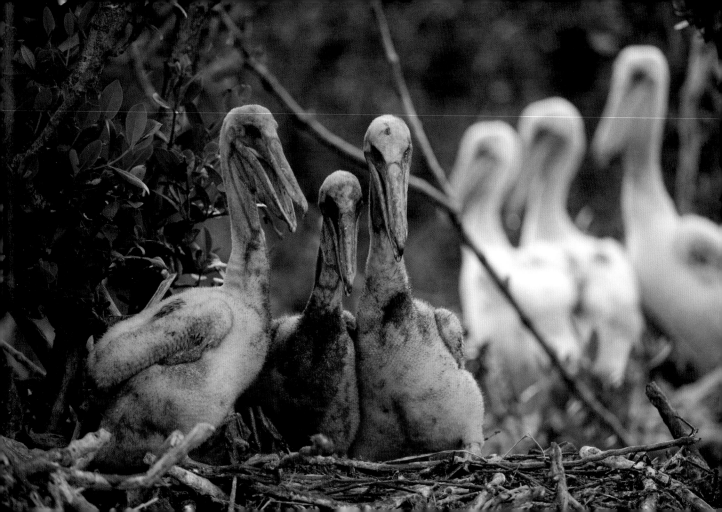

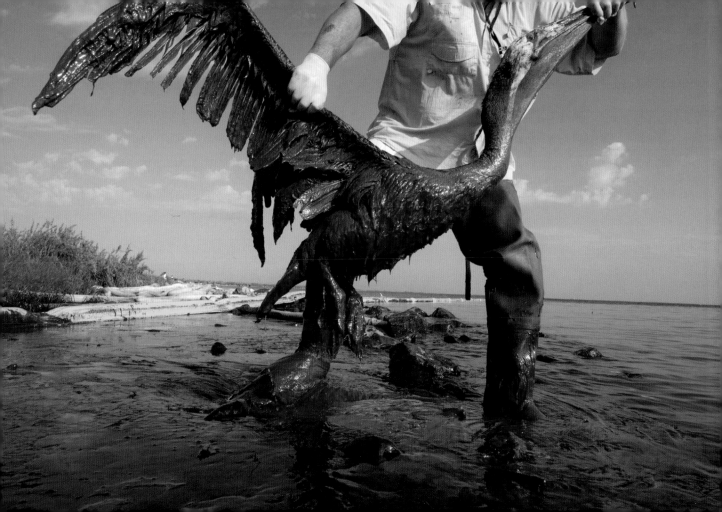

couldn't give a pickup truck away. Folks even started riding bikes and walking to work, which is a good thing, by the way.

Reduced consumption means the Earth breathes a little easier. Higher fuel costs also mean innovation in home building, manufacturing, transportation, and alternative energy. So it's not all bad by a long shot. And it's work that needs doing anyway. Remember: we're running out of oil.

They say people must be made really uncomfortable to change their behavior. Market forces like higher fuel costs are what make us sweat, not oil spills. People will consume less, and think more, only when the price we're all paying goes up and stays up.

Maybe that'll finally get us talking, even at our high school reunion.

The rescue of an oil-soaked pelican in Plaquemines Parish, Louisiana. The big question from the spill: Do we Americans care enough to prevent this from happening again? Or is the price at the pump all that matters?

Afterword

At its core, this book is a collection of short essays I've written for *CBS News Sunday Morning*. As simple and short as they may be, most took a surprising amount of time. I'm glad I had plenty of help along the way.

My wife of twenty-six years, Kathy, had to suffer through endless readings. My staff, Katie, Grace, Kyle, and Amy suffered as well. My friend Jeff MacGregor, one of the finest writers on the planet, consistently mentored me, no matter how busy he was. Bison Books manager Tom Swanson had the faith to bring this series of verbal musings to the printed page.

Above all, my thanks go to Rand Morrison, executive producer of *CBS News Sunday Morning*, who made the decision to air

many of these essays. My producer at CBS News, Judith Hole, has my deepest thanks too. Though she's a hardened broadcast veteran with a love for New York City so deep that she's got concrete in her veins, she is always patient, encouraging, and kind.

At the end of the day, I am a journalist, and I live through those around me. In words and pictures, I am a voyeur, peeking in on the lives of others, perpetually reliant on the kindness of strangers. I may grouse about human nature, but I'm always grateful—for a profession that has brought me the world, for stories shared, and for audiences who still pay attention.

Thank you.

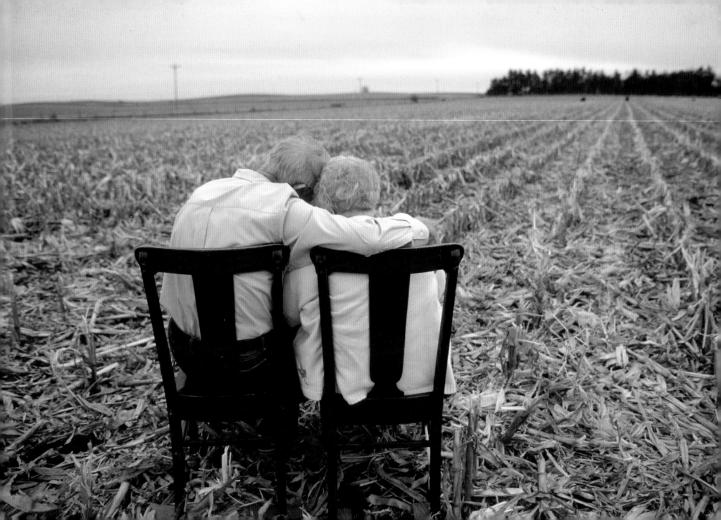

Also by Joel Sartore

RARE: Portraits of America's Endangered Species

Photographing Your Family

Visions of Lincoln (contributing photographer)

Nebraska: Under a Big Red Sky

Face to Face with Grizzlies

The Company We Keep

www.joelsartore.com

2009004157